ALBERT BIERSTADT

ALBERT BIERSTADT

by Matthew Baigell

Watson-Guptill Publications/New York

For the Moses and Edelstein families

Front cover: *The Oregon Trail, 1869*
The Butler Institute of American Art
Youngstown, Ohio.

Paperback Edition, 1988
Copyright © 1988, Watson-Guptill Publications, Inc.

First published 1981 in New York by Watson-Guptill Publications,
a division of Billboard Publications, Inc.,
1515 Broadway, New York, N.Y. 10036

Library of Congress Cataloging in Publication Data
Baigell, Matthew.
 Albert Bierstadt.
 Bibliography: p.
 Includes index.
 1. Bierstadt, Albert, 1830–1902. 2. West
(U.S.) in art. I. Title.
ND237.B585B3 759.13 81-3329
ISBN 0-8230-0494-5
ISBN 0-8230-0493-7 (pbk)

Manufactured in Japan

PREFACE

While preparing this study of Albert Bierstadt's paintings, I kept separate the three units of the text—the chronology, the essay, and the discussion of the plates. Although some repetition was necessary, each is a distinct entity and should be read in sequence to obtain a rounded picture of the artist. In the last unit I considered both stylistic and iconographic matters according to the nature of the work under discussion but without following any particular scheme. Despite Bierstadt's popularity and the general diffusion of knowledge concerning his works, this is the first extensive consideration of his style. Surprisingly, many of Bierstadt's paintings, even major works, are still not accurately dated. Since such a task was beyond the scope of this book, I have generally followed the dates given elsewhere. I do, however suggest interpretations of several works and aspects of Bierstadt's career that reach well beyond those offered by the authors of the two principal sources of information about Bierstadt; Richard Trump's "Life and Works of Albert Bierstadt" and Gordon Hendricks's *Albert Bierstadt: Painter of the American West* are essentially biographical studies.

I want to express my thanks to Renee Baigell and Sylvia Bakos for their observations on matters of pictorial style, to Barbara Listokin for discovering and alerting me to the existence of the Bierstadt sketchbook in the Rutgers University Library, and to Barbara Mitnick for information on Düsseldorf. I also want to thank Renee Baigell, Howard Green, and Dr. Allen Kaufman for sharing with me their knowledge of the cultural history of the period.

Finally, I want to thank the Watson-Guptill staff who have contributed their efforts to this book: Dorothy Spencer, Senior Editor; Betty Vera, Associate Editor; Elisabeth Mashinic, Editorial Assistant; Barbara Wood, who copy-edited the text; Jay Anning, who designed the book; and Ellen Greene, who supervised the graphic production.

CHRONOLOGY

The chronology is derived from Richard S. Trump's dissertation, "Life and Works of Albert Bierstadt,"
and from Gordon Hendricks's *Albert Bierstadt: Painter of the American West.*

1830 Born on January 7 in Solingen, Germany, near Düsseldorf, the son of Henry and Christina Bierstadt.

1832 Immigrates with family to New Bedford, Massachusetts.

1850 Advertises as teacher of monochromatic painting in New Bedford.

1851 Exhibits a few paintings locally. Perhaps teaches in Boston. Exhibits at New England Art Union in this and following year.

1853 Exhibits at Massachusetts Academy, Boston. Arrives in Düsseldorf late in year to study with mother's cousin, Johann Peter Hasenclever, who dies while Bierstadt is in transit. Does not register at Düsseldorf Academy of Fine Arts but learns from observation and experience.

1856 Early in summer, tours Germany and Switzerland and in October heads for Italy; remains there almost a year. Visits Florence, Rome, and Naples. Travels at times with William Stanley Haseltine, Henry Lewis, Worthington Whittredge, Sanford Robinson Gifford, and Emanuel Leutze.

1857 Arrives in New Bedford in autumn. Tours New England soon afterward.

1858 First works are shown at National Academy of Design, New York City, in April. Helps organize exhibition of paintings in New Bedford.

1859 In April joins survey team of Colonel Frederick W. Lander, chief engineer of the northern group of the Pacific Coast Railway Survey, whose purpose that summer is to survey a proposed rail route through the South Pass in Wyoming. Travels with F. S. Frost and other artists. After returning, moves to New York City in November and settles in famous West 10th Street Studio Building.

1860 Tours White Mountains with his photographer brothers, Charles and Edward.

1861 In fall, tours Union lines with Emanuel Leutze near Washington, D.C., but he does not participate in Civil War.

1863 In April, travels west with writer Fitz Hugh Ludlow. Visits Yosemite Valley in August for seven weeks. Also explores Oregon and Columbia River area. While in San Francisco, meets famous preacher Thomas Starr King and becomes familiar with western views of photographer Carleton Watkins. Returns to New York City in December.

1864 *The Rocky Mountains*, exhibited in New York City's Metropolitan Fair in April, brings immediate fame.

1865 Builds Malkastan in Irvington-on-Hudson, a home Bierstadt will rarely live in.

1866 Marries Rosalie Osborne Ludlow, former wife of Fitz Hugh Ludlow.

1867 In June, travels to England, is presented to Queen Victoria on the Isle of Wight, and tours Continent. Awarded Legion of Honor by Napoleon III, who does not meet Bierstadt until 1869. Returns to United States in 1869 and visits New England.

1870 Visits Europe briefly.

1871 In summer, returns to California for two-year stay. Meets photographer Eadweard Muybridge and geologist Clarence King by 1872.

1875 Completes *The Discovery of the Hudson* for U.S. Capitol.

1876 Makes several trips to Canada for social and recreational purposes. Also travels to Colorado and makes repeated trips to West in succeeding years, including northern plains states and Alaska. Stays in White House as guest of President Rutherford B. Hayes.

1877 Makes first of several trips to the Bahamas because of wife's declining health.

1878 *Expedition under Vizcaino Landing at Monterey, 1601*, completed in 1875, is second and last work purchased by federal government. Leaves for Europe in July and remains for one year. Returns to Europe frequently in 1880s and 1890s.

1881 Visits Yellowstone area for first time.

1882 Malkastan burns, and its contents are destroyed.

1886 Receives Order of Medjid from sultan of Turkey but is bypassed by younger generation. Works begin to be turned down for exhibitions, culminating in rejection of *The Last of the Buffalo* for Paris Exposition of 1889 and *The Landing of Columbus* for World's Columbian Exposition (Chicago) in 1893.

1893 Rosalie Bierstadt dies in Nassau, the Bahamas.

1894 Marries the wealthy Mary Hicks Stewart, widow of banker David Stewart.

1895 Declares bankruptcy in January.

1902 Dies on February 18 in New York City.

LIST OF PLATES

ALBERT BIERSTADT

WE CAN OFTEN TELL ABOUT AN artist's personality from the work he or she creates. This is not necessarily true of Albert Bierstadt, however, because he seems to have been three artists in one. The first Bierstadt, perhaps the authentic one, was able to make quick, brilliant sketches of atmospheric conditions, animals, and landscapes (Plate 26 and Figure 2). The second Bierstadt was the author of charming, intimate studies of vacation scenes, mountain parks, and genre subjects (Plate 24). The third and best-known Bierstadt was the orchestrator of mammoth paintings of western American scenery (Plate 11). The first Bierstadt was discovered in the 1960s when his small, brightly colored, almost abstract studies were seen in relation to then popular Mini-mal Art.[1] The second Bierstadt, who was not very well known in his time, remains largely unrecognized in ours. The third Bierstadt, however, enjoyed phenomenal success in the 1860s and 1870s, aroused serious criticism almost at once, and was largely forgotten before his death in 1902. All three personas provoke great interest, but we are concerned mostly with the last one since Bierstadt poured so much energy into that aspect of himself and clearly wanted to be remembered by those paintings.

One problem that should be faced at once is the failure in his own lifetime of the Bierstadt of the grand machines. Not all the reasons for that failure depend on questions of style or preference. Rather, they might also be concerned with the ways Americans choose to regard artists. It is of some importance to note that of the most famous painters of large canvases in the late nineteenth century—Bierstadt, Frederick Church (1826–1900), and Thomas Moran (1837–1926)—Bierstadt had the worst, even an angry, press.[2] Perhaps his critics found his large paintings inauthentic because they thought his interest in wilderness views grew from calculating his chances for sales rather than from a genuine delight in nature. For, unlike many artists who are designated "serious," Bierstadt traveled the high-society circuit and collected friends and acquaintances in the White House and in Europe's royal courts. He gave and went to elegant multi-course dinners on two continents. He delved, for the most part unsuccessfully, into moneymaking business ventures and even tried his hand at influencing foreign policy. His large paintings, obviously made for a wealthy clientele, have a grandiosity about them not unlike his social pretensions and the large and posturing business aspirations of his patrons. Although he had a studio in the famous Studio Building on New York City's West 10th Street and was an indefatigable worker, he was an outsider in the American artistic community. Bierstadt was not really one of those committed, with varying degrees of humility, to the making of art; rather, he deliberately sought fame and fortune. Perhaps his lack of subtlety disturbed his contemporaries, and when tastes changed, he became an easy target.

Tastes did change after 1875, and Bierstadt did try to cater to them in his smaller works. Intimacy, sentiment, and mood replaced controlled and relatively impersonal descriptions of landscapes. Brushy technique substituted for meticulous and dryly rendered detail. The new taste also called for emotional involvement in landscapes, which was foreign to Bierstadt's grand style.

The new tendencies emanating from Barbizon in France and Munich in Germany were carried to America by artists who studied in those centers and helped create the first American avant-garde, pallid though it was. Previously, American landscape paintings and genre scenes had in some way been linked to a sense of national purpose. They described the beauties of the American wilderness, the real or imagined ways in which rural Americans lived in harmony with the land, and the common activities of average Americans. After 1875 artists began to ignore these connections to their country's destiny, institutions, and customs in order to cultivate their own sensibilities. This seismic shift left Bierstadt, as well as Church and Moran, in the unenviable position of supporting a point of view progressive artists no longer took seriously. Bierstadt, who had produced many of the most bombastic paintings in the earlier mode, suffered the greatest loss of reputation, as much for his work as for his personality. Today, in a pluralistic art world where progress is no longer measured by the replacement of one dominant style with another, it is important to look with renewed interest at Bierstadt's paintings—to discover their inherent qualities and to read them in the larger context of American culture.

BIERSTADT'S DECISION TO STUDY IN Düsseldorf was a reasonable one. His mother's cousin, Johann Peter Hasenclever (1810–53)—who died shortly before Bierstadt arrived—was a significant artist there. The city had grown increasingly popular during the 1850s as a place to study art, and from 1849 to 1861 the Düsseldorf Gallery, featuring paintings of the Düsseldorf school, flourished in New York City.[3] George Schwartze, who went to Düsseldorf in 1839, was probably the first American to study there. Key figures such as Emanuel Leutze (1816–68) lived there from 1840 to 1859, Richard Caton Woodville (1825–55) from 1845 to 1851, and Eastman Johnson (1824–1906) from 1849 to 1851. Artists whom Bierstadt met in Düsseldorf include Worthington Whittredge (1820–1910), there from 1849 to 1854; Enoch Wood Perry (1831–1915), from 1852 to 1854; William Stanley Haseltine (1835–1900), from 1855 to 1857; Charles Wimar (1828–62), from 1852 to 1856; and Henry Lewis (1819–1904), from 1853 until his death. Bierstadt might also have heard of George Caleb Bingham (1811–79), who arrived about November 1, 1856, for a two-year stay when Bierstadt was passing through Rome on his way to Naples.

Wimar, Lewis, and Bingham possibly helped provoke Bierstadt's interest in the American West. Wimar, based in St. Louis from 1843 until he left for Europe, painted a western panorama in 1849 as well as works with Indian themes while in Düsseldorf. Lewis published *Das Illustruite Mississippithal* in Düsseldorf in 1854, which included illustrations of Indian life. Bingham had been painting western settlement scenes since the late 1840s.

In any event, the painting techniques and attitudes toward subject matter that Bierstadt acquired in Düsseldorf were more immediately consequential than the subject matter itself, but these are very difficult to determine with certainty. Influential German artists such as Carl Friedrich Lessing (1806–80), Andreas Achenbach (1815–1910), and Johann Peter Hasenclever were not members of the academy's teaching staff, although they lived in Düsseldorf. Johann Wilhelm Schirmer (1807–63), an academician since 1830, left Düsseldorf in 1854 to run the art school in Karlsruhe and was replaced by Hans Gude (1825–1903), who became a professor in 1854. Bierstadt might also have picked up stylistic traits from Leutze and Whittredge, with whom he became intimate and went sketching.

Of the major types of painting popular in Düsseldorf—history painting, historicized genre, anecdotal genre, landscape, and genre-ized landscape—Bierstadt was attracted to the last three categories and especially to landscape and genrelike landscape. The treatment of landscape as a major theme of the Düsseldorf school began as early as 1816, when Lessing first settled there, and was institutionalized in 1839 when Schirmer established landscape classes at the academy. By the time Bierstadt arrived, an ample landscape tradition was

available to him, ranging from Lessing's older, romantically emotional manner to Achenbach's Dutch-influenced realistic style, which was popular by the middle 1840s. Whatever their particular style, Düsseldorf landscape paintings usually contained elements that can also be found in Bierstadt's later works: abrupt tonal contrasts of light and dark, lighting sources hidden behind clouds, tortured-looking trees, agitated and dramatically rendered skies, and craggy landscape features often conveying an anxious mood.

Although Schirmer had left for Karlsruhe in 1854, Bierstadt might have absorbed at least two specific elements from his landscapes: an open foreground encompassing a vast sweep of valley or plain, and groups of trees placed in the center of a painting instead of being used as a framing device. From Achenbach, Bierstadt might have learned to pay attention to both the transparent and the reflecting qualities of water. Gude's habits of using a belt of dark-colored trees or ridges in the middle distance to separate foreground from rear ground and allowing oddly placed trees to emerge in isolation from deep gorges can be seen in Bierstadt's later landscapes. Finally, even though Bierstadt seems to have absorbed only general effects from Lessing's charged landscapes, the older artist's delicate and quietly meditated pencil and watercolor studies from nature possess the kind of abstract, planar vision that recurs repeatedly in Bierstadt's small nature studies.

The Düsseldorf school has been blamed for Bierstadt's inclination to revel in exacting detail. Although this quality pervaded American art during the 1850s and 1860s, Bierstadt's dryness of tone and often monochromatic and monotonal passages of pigment, unenlivened by variations in color and tone, probably persuaded critics to see much more detail than was in fact included. (Even in later works, where his style was looser and more brushy, he did not vary passages of pigment to the same extent as his contemporaries.) However sensational a view might be, Bierstadt hardly altered surface textures, colors, and tones. In his very large paintings, this sameness of finish could be damaging.

Bierstadt's critics might also have been disturbed by his occasional inability to integrate forms with their immediate spatial environment. A single tree, for example, might stand out too sharply from surrounding trees. Bierstadt's problem with detail lay not in its overabundance but in its visual isolation. Individual forms stand out and interrupt movement between larger units; their edges are too taut and their colors and tones too distinct from surrounding forms. Such individual forms often seem to lie on the picture surface rather than to assume their appropriate spatial position, thus inhibiting an easy and continuous reading of three-dimensionality. Yet it must be said that Bierstadt did possess a remarkable ability to suggest the breadth as well as the depth of western American spaces.

No doubt, the characteristic of isolated forms inhibiting spatial flow contributed to American criticisms of Düsseldorf school art. In *The Crayon*, the most important American art magazine of the time, a critic wrote in 1856 that Düsseldorf-inspired landscape painting lacked a sense of spirit, "the higher and more significant attributes of sunlight, space, her freedom and waywardness." A tree, to this observer, was lifeless and joyless unless one could "feel its openness, its graceful obedience to the winds of heaven—its breezy interstices, where birds may sit and sing."[4] In other words, that evanescent quality called spirit could more easily be experienced if the air seemed to penetrate the picture plane and to surround objects, providing them with the potential for movement.

These criticisms of the Düsseldorf manner are, by extension, criticisms of Bierstadt's paintings. They are important to consider in comparison to the paintings of another very popular artist of the 1860s, Frederick Church. He accomplished what it seems Bierstadt could not: no matter how thorough the detail, space and air seem to eat into the edges of landscape forms in Church's canvases, filling them with a consistent and continuous spatial flow. Luminist artists such as John Kensett (1816–72) and Fitz Hugh Lane (1804–65) also worked in as much detail as Bierstadt, but they, too, filled their paintings with a continuous spatial motion by softening coloristic and tonal transitions and unifying surfaces with an overall monocolor cast (usually blue or yellow). This latter feature—the modification of local colors of objects—helped provide air with palpability and in our own day has prompted art historians to state that Luminists painted light itself rather than blue- or yellow-shaded objects.[5] Although Bierstadt could and did paint in this manner (Plates 3 and 26), he was visually oriented toward more explicit differentiation and separation of forms, which resulted in the interruption of spatial continuity. Parenthetically, this characteristic might have been reinforced by the exhibition of paintings of the Pre-Raphaelite Brotherhood, which Bierstadt probably saw in Boston in 1858 after he returned from Europe.

The Land of Promise *and the* Canaan *of our time is the region which, commencing on the slope of the Alleghenies, broadens grandly over the vast prairies and mighty rivers, over queenly lakes and lofty mountains, until the ebb and flow of the Pacific tide kisses the golden shores of the El Dorado.*[6]

Sentimentalism over nature and the Indian because of guilt feelings concerning their exploitation and extermination was a romantic reaction. It was therefore more popular as a theme for artist and author than as a guide to practical political conduct.[7]

IN ONE SENTENCE, THE FIRST CITA-tion sums up two basic ways of imagining the West: as a biblical land awaiting the arrival of white Americans embarked on the holy mission of settlement, and as a land awaiting economic exploitation by white Americans. The second citation concerns how the artist chose to present the West to a public hungry for visual images of mountains, deserts, and Indians. Should the artist paint the West as a wilderness, as an Edenic garden, or as a harsh place for survival? Should his images have any relation to the ever westward press of settlement, exploitation of the land, and rising industries? That is, should scenes be limited to the land (and in which of its different aspects) rather than to the white man's actions on the land? What of the Indians—generally despised by western travelers and the imperialists who wanted the United States to grow to continental size? Should artists paint Indians merely as a sop to the consciences of those hell-bent on achieving Manifest Destiny? Or should images of the Indian devolve from general theories of culture and myth (the Noble Savage, for example) rather than from political realities? These two citations, written a century apart, help define the questions one must ask when trying to understand the broad implications of Bierstadt's western paintings, but they offer no help in formulating definitive answers.

Bierstadt returned to New Bedford from Europe in the summer of 1857. Within about a year and a half, he had embarked on the first of several western trips. In great measure, the trip determined his future artistic career. If Bierstadt ever indicated his reasons for traveling west in 1859, they have not survived. He does not seem to have kept personal records, nor do his surviving letters indicate a ruminating mind given to self-analysis or, for that matter, self-doubt. Neither do his paintings ever seem tentative or reflective.

We might surmise, nevertheless, how he could have been attracted to the West. An editorial in a contemporary issue of the *Cosmopolitan Art Journal* (1858) advised artists to find new subjects to paint—"anything without that everlasting stream, that inevitable hill."[8] Bierstadt, his business instincts ever acute, probably considered the West a prime subject to exploit. And, given his peripatetic nature (he probably logged more miles than any other artist of his era), it is almost surprising that he waited a year and a half to take his first overland journey. Few artists as well trained as he had ever recorded trans-Mississippi scenes. Yet a virtually insatiable demand for knowledge, both factual and visual, must have been immediately apparent to him upon his return from Europe. The Pacific railroad surveys of 1853–54, organized by Congress to determine the best routes across the continent, generated vast governmental and popular literature as well as enormous interest in the West, especially after the final twelve-volume congressional report was published between 1855 and 1861.[9] In the years

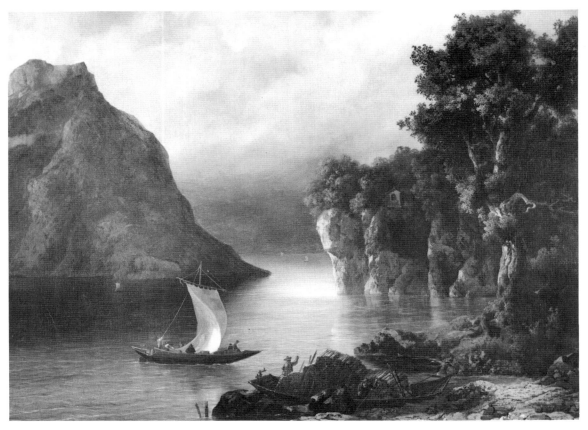

Figure 1. *Logging in Bavaria, ca. 1856. Oil on canvas, 33″ × 46″ (84 × 117 cm).*
Permanent collection, Sheldon Swope Art Gallery, Terre Haute, Indiana.

immediately preceding Bierstadt's initial trip, several books of travel, description, and settlement appeared, including Josiah Gregg's *Commerce of the Santa Fe Trail* (1844), the *Catalogue of Pictures in Stanley and Dickerman's North American Indian Portrait Gallery* (1846), Francis Parkman's *The Oregon Trail* (1849), Edwin Bryant's *What I Saw in California* (1849), S. N. Carvalho's *Incidents of Travel and Adventure in the Far West* (1859), and Rufus Sage's *Rocky Mountain Life* (1859). Almost every issue of *Harper's New Monthly Magazine*, *The Atlantic Monthly*, and occasional issues of *The North American Review*, as well as other periodicals, carried factual and fictional articles on the West during those years. The four great geological surveys sponsored by the War Department and the Department of the Interior from 1867 to 1879, which were concerned primarily with economic and scientific data, prolonged the demand for information throughout the remainder of the century. In fact, one might say that a major preoccupation of the government as well as the nation's inhabitants was the "grand national reconnaissance of the entire trans-Mississippi country," the documentation of its flora, fauna, geology, and inhabitants (native and Euro-American).[10] But the West was an area that required more than topographic documentation if it was to come alive in the minds of easterners.

Whatever his motives for traveling to the West, Bierstadt obviously responded profoundly to its varied scenery. Unfortunately, we do not know why he chose to specialize in wilderness scenery or whether his attitudes changed over the decades. Bierstadt became, in effect, one of the key artists to portray the grandeur, the spaces, and the stark contrasts between mountains and valleys for non-travelers and for those who wanted mementos of their experiences in the wilderness. He was the painter who best domesticated the West, eliminating its least pleasant aspects and making it an appropriate subject for an elegant sitting-room wall.

Because Bierstadt was a neophyte western traveler, his decision to join Colonel Frederick W. Lander's railroad survey of the area around the South Pass in Wyoming was a good one. By 1859 steamboats had made the Missouri River basin the most accessible region of the Far West. International figures had visited the area, including Maximilian, Prince of Wied, in 1832–34, and Prince Paul of Württemberg in 1851. This is not to say that the journey was an easy or a safe one; a few years earlier, in 1853, artist Richard Kern, a member of a railroad survey group in Utah, had been killed by Indians. Photographer Ridgeway Glover met the same fate in 1866. Bierstadt's route, however, was well known and well documented.[11]

His most extended statement is contained in a letter, only four paragraphs long, which he wrote on July 10, 1859, for *The Crayon*.[12] Toward the Indian, Bierstadt offered the usual majority-culture shibboleths. He found them "appropriate adjuncts to the scenery" and worthy of recording in paint if for no other reason than that their manners and customs "are still as they were hundreds of years ago." He continued, "Now is the time to paint them for they are rapidly passing away and soon will be known only in history. I think that the artist ought to tell his portion of their history as well as the writer." In fact, Bierstadt, who lost a large collection of Indian artifacts in the fire at Malkastan, observed the Indians hardly at all. He tended to use them at best only as "appropriate adjuncts," or at worst in a crass, racist way, as in the late series showing Columbus arriving in the New World (Plate 27). Probably Bierstadt included the remark about the Indians as a passing comment on an earlier *Crayon* article on them in which the reader was reminded that future generations would have to "trust to our scanty records for their knowledge of his [the Indian's] habits and appearance," for "he is fast passing away from the face of the earth."[13] The article then suggested that the Indian should be portrayed as a wild aborigine, "a sublimely eloquent representative of the hidden recesses and the mental solitude of the uncivilized wilderness," rather than as a semicivilized and subjugated person. In effect, the author wanted to see the Indian of myth and romanticized fiction, the dignified Noble Savage, brave and honest. The alternatives were to portray the Native American as a "savage harlequin lost in a cloud of feathers and brilliant stuffs" or as a barbarian reveling in skulls, scalps, and carcasses. Each of these attitudes—the earnest Indian, the costumed vaudevillian, and the sociopath—represented white fantasies. Probably the consensus in the art world at that time, and perhaps the least offensive attitude, was that the Indian was a Noble Savage.

For example, in an issue of *The New Path*, another art magazine of the period, Indians living on the plains were considered to dwell in "pristine simplicity, hunting, fishing and worshipping in the narrow verge to which the cruel rigor of the whites has pushed them."[14] Actually, those who advocated this point of view assumed that the Indian, living harmoniously in a state of nature, really inhabited a native variant of Arcadia. When Bierstadt's *The Rocky Mountains* (Plate 11) was exhibited in 1864 in New York's Metropolitan Fair, George Bancroft, the historian, wrote that on those eternal plains "you see the village of the wild people, who, like the mountains, are of unknown antiquity, and like them are basking in the light, full of life and mirth and action of their own, yet all of it life and mirth and action that are but the reflection and exponent of the inanimate scene. . . . The one is the fulfillment and embodiment of the other; the mountains find themselves reflected and

revealed in a living generation of men, as wild and as joyous as themselves; the two blend together, making the picture . . . one action, one landscape, one harmonious whole."[15]

The more common contemporary view was decidedly less friendly: "The red man of reality is not the red man of poetry, romance or philanthropy. He is false and barbaric, cunning and cowardly. . . ." It was also thought that he would eventually disappear from history before the advance of the morally and intellectually superior—and more aggressive—Anglo-Saxon race because he did not make the land productive.[16] Bierstadt, whether consciously or not, could easily tolerate this point of view. In the leaflet accompanying the exhibition in 1864 of *The Rocky Mountains*, the following words, of which Bierstadt must have been aware, appeared: "Upon that very plain where an Indian village stands, a city, populated by our descendants, may rise and in its art galleries this picture may eventually find a resting place."[17] The Indians would be replaced by a painting commemorating their earlier presence and nothing more.

Speaking of the same painting, Henry T. Tuckerman, the famous art writer of the time, reveled in the imagined pleasures of living in the wide-open spaces, hunting game, and waking with the morning dew on one's face.[18] By contrast, travel writers, not as effusive about camping out as the homebound Tuckerman, tended to concentrate more on realistic description than on Arcadian fantasy. (Staying dry in thunderstorms and warm in snowstorms were not easy accomplishments.)

We know nothing of Bierstadt's feelings about being in nature, although we must assume that he took both physical and spiritual pleasure in it. A few brief words in his letter to *The Crayon* (July 10, 1859) appear to contain his most extended statement on the subject. In it he compared the Rockies to the Bernese Alps, a literary conceit that associated a primitive and largely unknown American mountain chain with a more storied European one, reminiscent of Washington Irving's earlier comparison of the Catskills with the Apennines.[19] Bierstadt then described some scenes realistically, even prosaically. If the landscape provided spiritual uplift for him as it had for earlier figures such as Thomas Cole (1801–48) and Asher B. Durand (1796–1886), he did not say so. It would seem, rather, that Bierstadt found the wilderness visually stunning and geologically fascinating more than morally uplifting.[20]

Perhaps the closest approximation of Bierstadt's attitudes in contemporary literature was recorded by Clarence King in his *Mountaineering in the Sierra Nevada*, possibly the best book of its kind ever written. King, a distinguished geologist, led the War Department's geological exploration of the fortieth parallel from 1867 to 1873.[21] Concerning one view of the Sierras he wrote: "along its upper limit the forest zone grows thin and irregular; black shafts of alpine pines and firs clustering on sheltered slopes,

or climbing in disordered processions up broken and rocky faces. Higher, the last gnarled forms are passed, and beyond sketches the rank of silent, white peaks, a region of rock and ice lifted above the limit of life."[22] In this typical passage King combined natural and geological observation. He did not, as earlier writers would have done, invoke the Deity and point to a higher cause for all earthly things. Only occasionally would he allow himself to say that nature impressed him "in the dear old way with all her mystery and glory, with those vague indescribable emotions which tremble between wonder and sympathy."[23]

Another writer, Samuel Bowles, the influential editor of the Springfield, Massachusetts, *Republican* and an acquaintance of Bierstadt's, also wrote in phrases less lofty than those of the previous generation. Writing of the Yosemite Valley, he recalled "no Vision of Apocalypse so grand, so full of awe, so full of elevation," and declared that views of the Rockies cleared "the heart of earthly sorrow, and lead the soul up to its best and highest sources."[24] There were no lessons of high and holy meaning to be learned, no insights into the workings of the Deity, no revelation of God in nature, no templed groves of trees, and no readings of the vast universe in a small leaf. The scenery might elevate the soul, but it provided no vehicle for transcendence. The intellectual climate was such that God was still recognized as the Grand Author, but explorers, geologists, and artists alike were going to dissect his script carefully. An earlier generation of scientists and artists had synthesized: they had tried to fit all matter into a cosmic pattern with God at its apex. The new generation intended to analyze: they would break everything down into its components.

If we assume that Bierstadt's attitudes were like King's and Bowles's, it is apparent that religion or a belief in a unified scheme of things was not the primary organizing motif for him that it had been for Cole and Durand. Bierstadt instead re-created nature as a theatrical presentation, at least in his large paintings, where he replaced religion with an aesthetic of the secular sublime. In this regard he may be viewed as an artist who no longer saw the Deity as the prime motivating force in nature, but who was not yet ready to reduce nature to the dimensions of his own mind or to visual perceptions, as had many contemporary and younger Barbizon- and Impressionist-influenced artists. Bierstadt still needed a hook, as it were, and grandiose presentation served that purpose.

Bierstadt's landscapes lend themselves to other kinds of speculation. During the Civil War, but rarely afterward, writers searched for an American art based on American landscape and genre scenes. Seeking assurance in the continuity of the republic, they sought an art that represented American nationalism in the sense of a single nation. In an article in *The Knickerbocker* magazine in 1861, for instance, one author argued for artistic subject matter free from European sources.[25] Henry T.

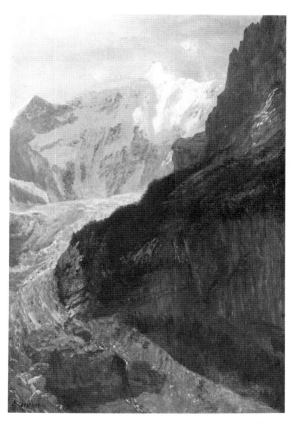

Figure 2. Finsterhorn, *n.d. Oil on paper, 11½″ × 7½″ (29 × 19 cm). Collection of the Herbert F. Johnson Museum, Cornell University, Ithaca, New York. Gift of Mr. and Mrs. Morris K. Bishop.*

Tuckerman found Bierstadt's *The Rocky Mountains* "eminently national," the most genuine and wonderful American work yet painted and "a grand and gracious epitome and reflection of nature on this Continent."[26] He thought that an art such as Bierstadt's could help bind the country together, and western wilderness views presumably might represent a new, unsullied America, reborn and reunited.

This point of view overlaps at least two other currents of thought of the time. The first is based on a geographic explanation of the nation's rise to world prominence and the second on the tricky concept of Manifest Destiny, the idea that the United States as a Christian country had a mission to regenerate the entire world spiritually. Probably the central text describing the first point of view is William Gilpin's *The Central Gold Region, the Grain, Pastoral, and Gold Regions of North America*.[27] Only two points need to be mentioned here. First, America was unlike other land masses such as the Alps, where central mountain areas cause rivers to flow centrifugally. Instead, the American land mass, with the incredibly vast and centralized Mississippi River drainage system, promised a brilliant and harmonious development of the entire nation.[28] Gilpin's second point, echoed by many

Figure 3. *William Henry Jackson, Panorama of the Uintas, 1871. Collection unknown.*

Figure 4. Echo Lake, Franconia Mountains, New Hampshire, 1861. *Oil on canvas, 25″ × 39⅛″ (63.5 × 99 cm). Smith College Museum of Art, Northampton, Massachusetts. Purchased with the assistance of funds given by Mrs. John Stewart Dalrymple (Bernice Barber '10), 1960.*

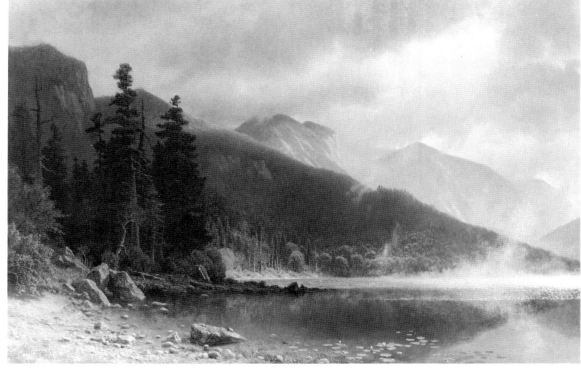

travel writers, was that "nature here [in the western mountains and their river systems], more perfectly than at any other point upon the globe, unites into one grand *coup d'oeil* all her grandest features, which, harmoniously grouped, present to the mind a combination of superlative sublimity."[29] In brief, Gilpin argued that America possessed the most appropriate geography of any nation and that the western portions of that geography were the most beautiful in the world. Bierstadt certainly labored tirelessly to illustrate that beauty for those who believed it true. (The idea of the West as the generating center of the nation, still an issue today, can be traced back as far as 1804.)[30]

Relating Bierstadt's paintings of the West to the concept of Manifest Destiny is less easy because there seems to be no indication of it in the literature about him and because Manifest Destiny contains at least three distinct elements. These are holy mission—the Anglo-Saxons are destined to revitalize the world spiritually; expansion and exploitation—the continent is available to aggressive people for development; and millennialism—God's kingdom on earth is imminent in Anglo-Saxon America.[31] Bierstadt's paintings of pioneers do illustrate expansionism (Plate 16). Holy mission is a more difficult matter. One of the problems seriously-minded people had with the concept was the unholy stain of slavery. How could the nation lead the world to peace, freedom, and happiness if it enslaved other human beings? For those people the Civil War was the supreme test which America passed with the abolition of slavery, enabling it to

take up its mission with righteous authority. In this light, perhaps, paintings of the wilderness represented New World innocence, an undefiled purity paralleling the new and revitalized purity of the American character. But since Bierstadt painted wilderness scenes before, during, and after the Civil War, such meaning does not adhere easily to his work unless he believed in America's holy mission regardless of the issue of slavery. In any event, that this point of view could flourish during the years of incredible corruption after the Civil War, when economic buccaneers robbed the government and settlers of their lands, attests to its hold then, as now, on the American mind.[32]

One last interpretation, which draws on all previous ones, might be the most pertinent, as well as the most cynical. Landscape painting, long acknowledged to be the most profound visual embodiment of the nineteenth-century American psyche, might also contain elements of self-deception. According to this line of thought, Bierstadt's large landscapes were initially so popular because they reflected the notion of empire, of imperial expansion across the continent and, by extension, to other parts of the world. In the minds of Bierstadt and his audience, Manifest Destiny may have included the notion that Americans did not have to live by moral principles but deserved what they could acquire simply because they were Americans. Manifest Destiny in this sense became a rationale for acquisition rather than a task of moral regeneration. Americans were blessed and merely had to take advantage of their geographical situation. As the editor of *Harper's New Monthly Magazine*

stated, "[The continent] is strikingly adapted not only to greatness of empire, but to that peculiar form of greatness which seems to be received for our inheritance. . . . Taken in its whole, it is a wonderful provision for the intelligence, sagacity, energy, restlessness and indomitable will of such a race as the Anglo-Saxon—a race that masters physical nature without being mastered by it—a race in which the intensest home-feelings combine with a love of enterprise, advent and colonization—*a race that fears nothing, claims everything within reach, enjoys the future more than the present, and believes in a destiny of incomparable and immeasurable grandeur* [italics added]."[33] The Rockies and the Sierras, more awesome than the Catskills and the White Mountains, embody the inheritance mentioned by the magazine's editor. Whereas an artist such as Thomas Cole sought God through nature and a life in harmony with nature and attempted to express those sentiments through his works, Bierstadt showed the landscape's overwhelming strength, beauty, and grandeur, as a metaphor for America's special and expansive place in the world.

BIERSTADT'S SUBJECT MATTER, whatever the category, ranged from the pleasant to the spectacular. In his wilderness views he focused on the sheer visual beauty of the western mountains, valleys, parklike areas, waterways, and waterfalls, avoiding those scenes of the desert or the plains that might convey discomfort. No matter how stupendous the view, he never commu-

nicated fear or isolation in nature. He shunned the painting of freakish, eroded forms, often mentioned in travel literature, that resembled human profiles, church spires, ships, or sails. Preferring scenes beyond frontier settlements, he rarely painted townscapes and never mining subjects. He depicted pioneers on the road rather than on farms. One would never learn from his paintings, or from those of other western artists, that the population of the trans-Mississippi West grew from two to twenty million between 1850 and 1900. His few genre scenes usually lacked particularization, obviously a self-imposed limitation despite his training in Düsseldorf. He rarely, if ever, explored individual character but allowed his figures to play only typecast roles. In an era of constant Indian warfare (after 1866), he painted Native Americans as essentially uninteresting and nonthreatening accessory figures. Perhaps he really did believe in the West as an image of visual perfection that could serve as an emblem for American civilization.

At the very center of Bierstadt's attraction to the West was the Yosemite Valley, which he first saw in August 1863. Although he was the most famous painter of Yosemite scenes, he was not the first to record its special features. Thomas Ayres painted there in 1855, and C. L. Weed in 1859 and Carleton Watkins (1825–1916) in 1861 photographed it. Bierstadt painted Yosemite scenes throughout his career—summer and winter views, the valley floor, its waterfalls, and its mountainous terrain. One of his largest paintings, measuring 116 by 180 inches (295 by 457 cm) was a Yosemite vista, *The Domes of the Yosemite* (1867). Considered the most beautiful place in the country, the valley was both a natural park and a natural paradise, seemingly wild, but because of the bordering cliffs and mountains measurable and tame.

To refresh his memory when painting Yosemite and other western scenes, Bierstadt used his own sketches as well as photographs.[34] He was familiar with photographic processes at least since his return from Europe in 1857, and he may have taken several stereographs during his first western trip in 1859. Bierstadt's brothers, Edward and Charles, were photographers, and the three spent the following summer in the White Mountains taking pictures, some of which were published in 1861 and in the book *Stereoptic Views among the Hills of New Hampshire* (1862). It was reported that Bierstadt selected the scenes to be photographed but did not operate the equipment.

Bierstadt also became familiar with the work of two or three major photographers of the West in subsequent years. He probably saw Watkins's photographs of the Yosemite Valley in Goupil's Gallery in New York City in 1863 before traveling west that year. He did study them carefully in San Francisco before leaving for the valley. Bierstadt may have recognized scenes from the photographs. The western views of Eadweard J. Muybridge (1830–1904) were probably known to him by 1868

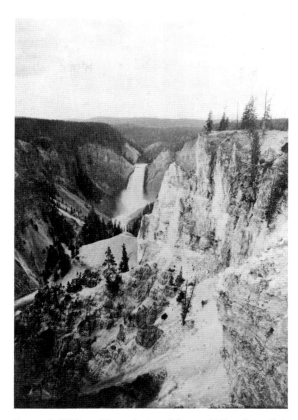

Figure 5. *William Henry Jackson*, Lower Falls of the Yellowstone, 1871. *International Museum of Photography at George Eastman House, Rochester, New York.*

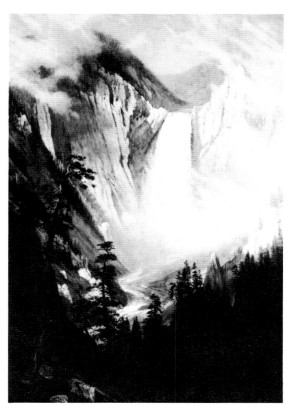

Figure 6. Yellowstone Falls, 1881. Oil on canvas, 43½″ × 29¾″ (110 × 75.5 cm). Courtesy of the Buffalo Bill Historical Center, Cody, Wyoming.

through publication in John Hittell's *Yosemite, Its Wonders and Its Beauties* (1868) and in the magazine *Philadelphia Photographer* (November 1869). But even if Bierstadt was not familiar with Muybridge's work at this time, he met the photographer in San Francisco in 1872 and traveled with him to Yosemite that summer. As with his brothers in previous years, Bierstadt acted as Muybridge's artistic adviser. Bierstadt undoubtedly also knew the photographs of the Yellowstone area taken by William Henry Jackson (1843–1942) in 1870. Bierstadt's old friend Sanford Gifford, with whom he had toured Italy in 1856 and 1857, accompanied Frederick V. Hayden's geological survey of the Yellowstone region in 1870. Jackson served as the survey's photographer, and his work presumably came to Bierstadt's attention through Gifford (Figures 5 and 6 and Plate 23).

All of this indicates that Bierstadt, whether as an adviser or as an operator of equipment, was clearly familiar with the photographic medium. But the significance of this is ambiguous at best. Bierstadt's Düsseldorfian attention to detail merged easily with the precise documentary influences of photography and with the pervasive scientific and factual interest in the West as exemplified by the various governmental surveys. James Jackson Jarves's contemporary observations of Bierstadt's work—that "the botanist and geologist can find

work in his rocks and vegetation" and that "he seizes upon naturalistic phenomena with naturalistic eyes"—were probably considered compliments, as far as they went.[35] But what of uniquely photographic elements? Do any exist in Bierstadt's work? Did they affect his overall mode of design? Surprisingly, Bierstadt rarely used distinctly photographic compositional formats (Plate 7). In several other instances the interaction is less clear, since painters and photographers looked at similar scenes and arranged forms in similar ways. For example, in his *Echo Lake, Franconia Mountains, New Hampshire* (1861), Bierstadt deemphasized the foreground and stressed the sloping profile of the hill in the middle distance, ignoring traditional Claudian formulas of balance and measured spaces (Figure 4). Sources might lie both in Carl Friedrich Lessing's landscape studies of the 1850s, which Bierstadt would have known in Düsseldorf, as well as in photographs of the White Mountains taken by his brothers in 1861.[36] Certainly there is a resemblance between Bierstadt's painting and William Henry Jackson's photograph of the Uinta Mountains, taken in 1871 (Figure 3). Furthermore, certain photographic stylisms that supposedly influenced Bierstadt, such as foreshortened logs placed on the diagonal to emphasize depth,[37] can be found in American landscape paintings done before the invention of the camera.

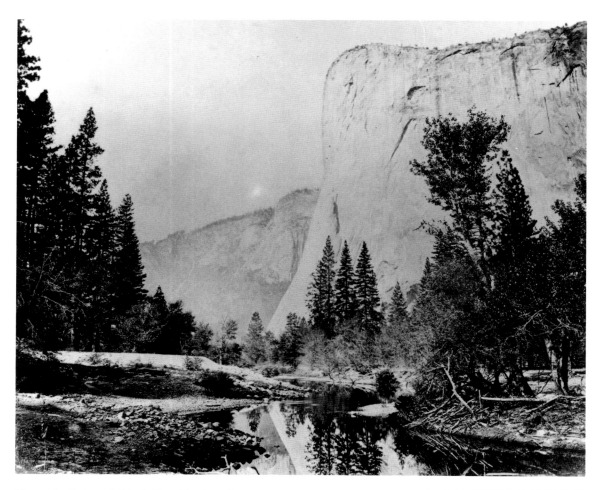

Figure 7. *Eadweard Muybridge,* Tutokanula, Valley of the Yosemite, *1872. University of California, Los Angeles, Department of Special Collections.*

Figure 8. *Carleton Watkins,* Mirror View, El Capitan, Yosemite, *ca. 1867. Rare Book and Manuscripts Division, The New York Public Library, New York City. Astor, Lenox and Tilden Foundations.*

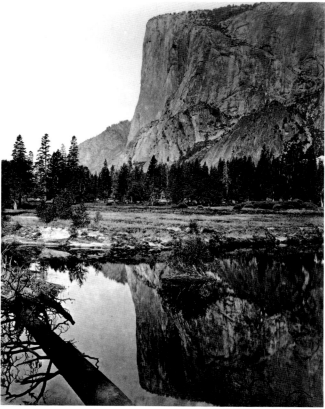

Nevertheless, Bierstadt did use photographs, but this means only that he studied them in addition to his own sketches. Comparing the works of Watkins and Muybridge is instructive here, since Bierstadt obviously looked at their photographs of Yosemite when painting scenes of the valley. In any comparison, one point becomes abundantly clear. Watkins was conscious, almost to a fault, of precise design relationships, of connective visual elements, of a clarity of units, of simplicity of parts, and of clearness and control of detail (Figure 8). Muybridge, by contrast, seems impetuous, recklessly cluttering the foreground, allowing jarring angular formations of rocks and mountain profiles to interrupt the flow of movement between units (Figure 7). While Watkins aimed for serenity, Muybridge captured the living spark of nature. In regard to Bierstadt, the question is not one of influence but of receptivity: To which photographer was he more responsive? The answer obviously depends on whatever effect he had in mind while painting a particular canvas. On the whole, his vision was more closely attuned to that of Watkins. Bierstadt kept a firm control over the number and arrangement of the elements of design, even in his most theatrical landscapes. Thus, to assign the source of a motif to one photographer or another answers only one part of the question concerning Bierstadt's relationship with photography.

LIKE SEVERAL OTHER ARTISTS BEfore and since, Bierstadt continued to paint in the style of his first maturity to his death, long past the time he was able to infuse his work with intensity and inner necessity. It is also true that, as his contemporaries, including Clarence King, pointed out in occasional mountainscapes he substituted cream-puffery for geology.[38] If these observations call into question Bierstadt's ability for continued inventiveness and consistency of craft, they also indicate that after he found his audience, he catered to its tastes. As noted by a recent observer of the American scene when describing tourists of Bierstadt's time, "Many of the tourists, new to matters of sensibility and taste, foreign to the leisurely quality that had been essential to the Grand Tour and to the mien of the dilettante, required an exaggerated stimulus, a supernormal signal, to kindle their responses."[39] Bierstadt, as much as any artist of his era, knew exactly how to translate that stimulus into art.

COLOR PLATES

Plate 1

A RUSTIC MILL

1855

When he lived in Düsseldorf, Bierstadt made extended sketching trips. From his studies he created several intimate landscapes and genre scenes in landscape settings. In these, a house, a barn, or a mill was placed in the middle distance, often near a pond or a brook. Rather than emphasize particular activities or suggest an anecdote, Bierstadt preferred to concentrate on general settings or typical scenes. This suggests that early in his career he was already more interested in the landscape than in genre. Although the mill is centrally placed in *A Rustic Mill*, it might also be considered a decorative accessory, a touch of local color that is the equivalent of the Indians Bierstadt used as scenic additions in later works.

Paintings from this period have been linked with those of Worthington Whittredge, with whom Bierstadt lived in Düsseldorf.[40] Both probably derived landscapes of this type from Andreas Achenbach, who was in turn influenced by seventeenth-century Dutch realists. Their mark can be seen, at some remove, in the detailed description of the cloudy sky, the trees, and the ground cover, especially along the stream's banks. The rutted road also adds a touch of peasant informality. The composition, too, reflects Dutch art in its almost studied indifference to classical balances. Trees do not frame a central vista, and the spaces, following the bend in the brook, tail off to the left; but the horizontal band of trees in the distance frames the group in the foreground.

Oil on canvas, 43¼″ × 58¼″ (110 × 148 cm). Hunter Gallery, San Francisco.

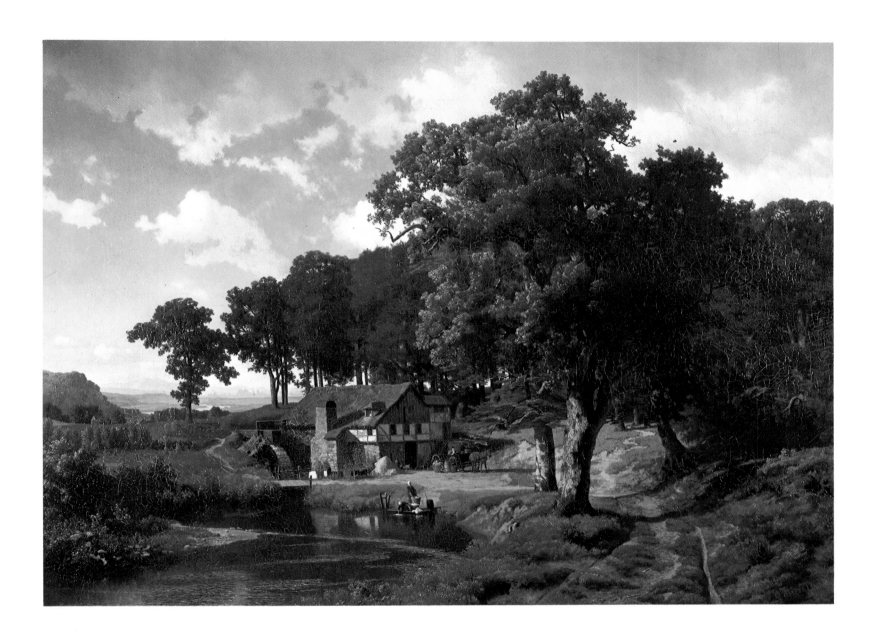

Plate 2

THE PORTICO OF OCTAVIA

1855

Johann Peter Hasenclever specialized in genre painting and often sparked his works with satiric touches. Had he not died before Bierstadt arrived in Düsseldorf to study with him, Bierstadt might have painted several more works like this one. By emphasizing so obviously the contrast between the tourists and the locals, Bierstadt might have intended this painting as an homage to his late relative. Certainly, he rarely created works filled with so many anecdotal elements and carefully observed details. The stagelike presentation of the characters was a feature of the Düsseldorf style, although Bierstadt relieved the claustrophobic shallowness of the stage by the slight diagonal recession of the portico's wall and by the roadway through the arch.

The painting is not unlike the scenes recorded in the travel literature of the time and in novels such as Nathaniel Hawthorne's *The Marble Faun* (1860).

Moldering walls have lost their plaster and reveal irregular brick courses. A bush grows from the capital at the base of the arch. Laundry hangs over the narrow street. The long stone table, obviously pilfered from an ancient monument, displays the day's catch. The locals, picturesque in their dress and playing stereotypical roles, chat animatedly or have been overcome by sleep, evidently in the midst of their labors. Dust is everywhere. Into this amiable scene intrude a couple from another world, the man clutching his guidebook and looking slightly offended by the lack of order, discipline, and cleanliness; the woman, slightly startled by the activity and noise. Their responses and subsequent conversation are predictable. Bierstadt ambitiously posed the figures in a variety of moods and attitudes, suggesting that, had he desired, he could have become a first-rate figure painter.

Oil on canvas, 28½" × 37" (72 × 94 cm). Courtesy, Museum of Fine Arts, Boston.

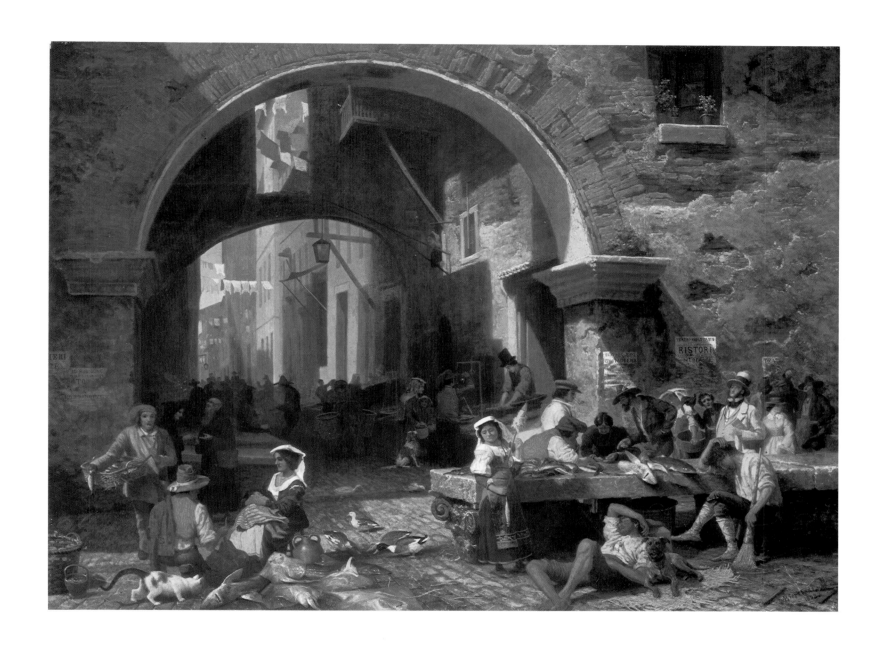

Plate 3

GOSNOLD AT CUTTYHUNK, 1602

1858

Bartholomew Gosnold (d. 1607), the English explorer and colonizer, sailed for the New World in 1602 and eventually landed on the coast of Maine. He then worked his way south to an island near Cape Cod which he called Elizabeth (now Cuttyhunk), where he landed and built a fort. From this story Bierstadt fashioned a remarkable painting, considering that it was completed a little over a year after he returned from Europe. In it he records his direct response to a shoreside scene, an utterly peaceful moment on a summer day at high noon.

Gosnold at Cuttyhunk has few of the Düsseldorf mannerisms of Bierstadt's earlier work. Gone are the clouds as well as the clotted and cluttered surfaces. In their place Bierstadt substituted a broad prospect and an open expansiveness—a quality of design he probably acquired in Italy. (For the record, Carl Lessing had painted panoramic landscapes in the early 1850s.) To the soft, melting atmosphere of Italy, however, Bierstadt added the clear and harder light of New England, at least in the foreground. Perhaps he had become aware of Luminist works by artists such as Fitz Hugh Lane. In any event, *Gosnold* is one of the few of Bierstadt's works to have Luminist characteristics: a low horizon line, considerable amounts of water reflecting a nearly cloudless sky, and isolated forms silhouetted against neutral backgrounds rather than clustered, superimposed detail. He also added what seem to be glazes of golden yellow to the entire surface to harmonize the elements of the painting and to emphasize the golden daylight.

But despite the Luminist qualities, certain Bierstadt traits persist. The brush strokes are visible and are more lively. Tonal contrasts of lights and darks—of sunshine and shadow—are more abrupt, as in the trees at the left. In this painting Bierstadt allowed studio lighting conditions to dominate his perception of outdoor light. The trees tend to writhe more than those of other American artists. And the colors of the hills to the right are too intense in comparison to those of Luminist works, in which distant forms are often unnaturally pale.

As in past and future works of Bierstadt, anecdotal incident is kept in the safe middle distance. It dignifies the landscape with human presence but does not force it to serve as a mere backdrop for human drama. The spaciousness of the scene, in part created by the sea merging with the sky at the horizon line, is rare in Bierstadt's work. As pleasant as it is, *Gosnold* marks a false start in Bierstadt's career. Had he persisted in exploring the compositional and coloristic ideas indicated here, he might have added a painterly breadth to Luminism; but his pictorial interests lay elsewhere.

Oil on canvas, 28" × 49" (71 × 124 cm). Old Dartmouth Historical Society Whaling Museum, New Bedford, Massachusetts. Gift of Miss Emma B. Hathaway.

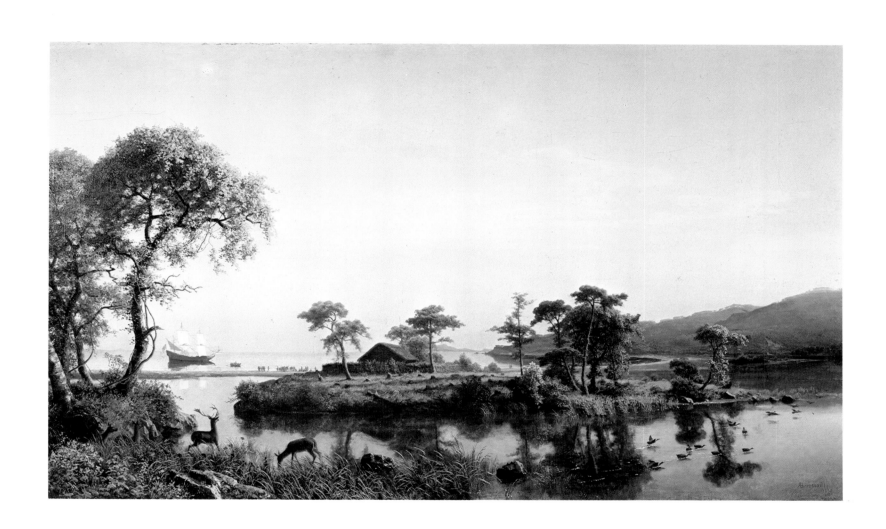

Plate 4

THE MARINA PICCOLA, CAPRI

1859

Bierstadt made several paintings based on his European sketches after returning to New Bedford, including scenes of Capri, the Bay of Naples, and Salerno, which he had visited with Sanford Robinson Gifford in the spring and early summer of 1857. The *Marina Piccola* is perhaps Bierstadt's finest, and most personal, realization of southern Italian scenes. Several compositional formulas that inform his later paintings appear here, including a broad, horizontal expanse of earth in the foreground, boats (later, fallen tree trunks) that point into the picture space to emphasize depth, rugged and occasionally odd-shaped mountains that add an emotional charge, a dramatic sky, and a sun that faces the viewer. Two additional features that would later become virtual signatures of Bierstadt are present here. First, the horizon line, from which the mountains spring, is relatively low. Second, there is a space-box type of composition in which mountains box in the foreground and middle ground, severely limiting movement into depth. Vistas tend to be closed. The placement of the Faraglioni Rocks, even with the open sea around them, is an early example of this space-controlling device. Within a few years the rocks in Bierstadt's work would grow to towering proportions, such as in the Rocky Mountain scenes (Plate 11).

Another early painting, *Logging in Bavaria* (Figure 1), also contains elements that Bierstadt later used on a monumental scale and may help explain his later fascination with the Yosemite Valley. In that work, a narrow finger of water reaches between flanking cliffs. Substitute a valley floor for the water, and we see in embryo a subsequent favorite compositional device. In addition, the sun—which the viewer faces—is hidden from view, throwing one side of the painting into shadow while illuminating the other (see also Plate 17). *Logging in Bavaria* also exhibits Bierstadt's disconcerting habit of finishing one part of a work meticulously (here, the right side) while leaving another section (the left) relatively incomplete. Although the left side is obviously meant to be in shadow, it is like the background hills of *Gosnold at Cuttyhunk* (Plate 3) in that it is not brought to the same degree of realization as the rest of the painting. As in Bierstadt's other works, the human figures are integrated into the landscape setting.

Oil on canvas, 42" × 72" (107 × 183 cm). Albright-Knox Art Gallery, Buffalo, New York. Gift of Albert Bierstadt, 1863.

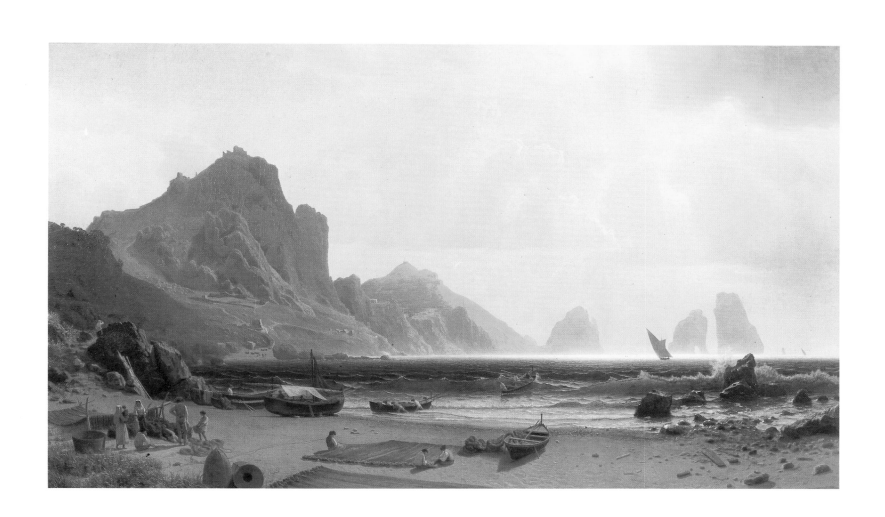

Plate 5

BERNESE ALPS, AS SEEN NEAR KUSMACH

1859

Based on earlier studies made on his trip through the Alps on the way to Italy, *Bernese Alps* was one of Bierstadt's most ambitious paintings to that time. A bucolic farm scene is surrounded by the fantastic wilderness of the Alps. Rarely would Bierstadt again try to show so much mileage. Compared with several of his American western scenes (Plate 7), *Bernese Alps* is the work of a young artist still adhering to tradition and precedent. The mountains provide compositional balance. Those to the extreme left and right are emphasized and raised, allowing the central area to appear as a bowllike hollow. Obvious crossing diagonals ensure the two-dimensional stability of the design. The lake to the left properly zigzags into depth, pulling our eyes toward the distant mountain ranges. The fir tree at the lower left which rises above the tree line and the leafed tree to the left of the house at the right are tied visually to the vertical contours of the mountains and link the lower and upper portions of the painting. The clump of trees at the center, probably derived from Andreas

Achenbach, is the hub of the composition around which space radiates. The clump's upper profile also serves as an important link in the diagonal that rises from the lower left along the mountain profile to the right. The cows in the foreground provide scale, allowing the viewer to measure the cleared field behind. These devices indicate that Bierstadt could organize a landscape on a grand scale.

Bierstadt's signature space-box motif is here fully developed in the distant enclosing mountains. This personal mannerism helped set off Bierstadt from his Luminist contemporaries in that it does not allow an easy visual connection and continuation between the earth and the sky. The sense of spiritual fluidity between matter and space is effectively broken, since one's eye is stopped by the enclosing forms, as if one were observing a giant stage set. For Bierstadt, the landscape always remained something at which to marvel rather than to witness as the transcendental experience of conjoining one's soul to nature.

Oil on canvas, 42″ × 71″ (107 × 180 cm).

Plate 6

SURVEYOR'S WAGON IN THE ROCKIES

ca. 1859

Although it is a small sketch, this work should be recognized as one of the talismanic paintings of the West. It probably records the shocking spatial disorientation triggered by seeing the endless plains and mountain ranges of the West for the first time. The wagon, the horses, and the rider are suspended in space somewhere in the open-ended plains. Except for the continuous mountains, there are no markers by which to measure anything—no wagon tracks, hoofprints, bushes, compositional diagonals, or zigzags. The travelers move through a land without leaving a trace and are unable to measure easily the miles they have traversed. There is no possibility of determining the yardage to the grazing animals except by means of atmospheric color; proximity and distance are based on clarity of contour and color alone. Ironically, this, too, is disorienting, since one can see both more and farther in the clear air of wilderness than in the polluted air of towns and cities.

For Bierstadt, the plains were probably impossible to organize into compositional units, a factor that might explain his preference for mountain-valley themes. A generation ago, this type of landscape might have been termed "alienated," since the artist refused to organize and control it.[41] Today we are more interested in process and mechanistic explanations and might call it a "nonstructured" or "nonspatialized" space. This kind of open composition was used later, in the late 1860s and after, in western paintings by Worthington Whittredge and John Kensett; Whittredge traveled west in 1866 and 1870, and Kensett in about 1856–57, 1868, and 1870.

Oil on paper on canvas, 7¾" × 12⅞" (20 × 33 cm).
The St. Louis Art Museum. Gift of J. Lionberger Davis.

Plate 7

THUNDERSTORM IN THE ROCKY MOUNTAINS

1859

Another small work, *Thunderstorm* is one of Bierstadt's most important and interesting early western paintings. It is probably the first of his works to be influenced by photography, both in its overall conception and in its details. We know that stereographs and photographs were taken during Bierstadt's first western journey and that his brothers were photographers, but it is not certain that Bierstadt himself actually took pictures.[42] Whether he did is less important than the fact that he had continued access to photographic documentation while painting *Thunderstorm*.

Traditionally, artists had painted landscapes from a slightly elevated point of view as if hovering several feet above ground. Bierstadt completed several in this manner throughout his career (Plate 19). Photographs, however, provided him with at least two alternate modes of pictorial organization. In one type (Plate 14), we seem to stand at ground level or slightly above, to look straight ahead to the base of the mountains (which serve as the horizon line), and then to see the mountains towering above us. This type was probably influenced by the mammoth photographs taken on plates as large as 22 by 25 inches (56 by 64 cm) by Carleton Watkins and others. *Thunderstorm* is of another type. In it the landscape—including the mountains—is compressed into the lower part of the canvas. The foreground and the middle and far distances all lie at or below eye level. This seems to have been the way the landscape appeared through the lens of a small camera.

At least four other characteristics of design traceable to photographic sources are evident here. First, there is an apparent laterally expansive foreground that really does not include a vast amount of land. Yet, by comparison, the middle and far distances include enormous amounts of space. Second, the ground at our feet seems to slip beneath us, suggesting the slight peripheral distortions of photographs. Third, boulders in the foreground stand out with three-dimensional clarity, recalling stereographs. Fourth, the dark row of hills in the middle distance, which are contrasted with the lightly toned distant mountains, might also show photographic influences, since near and far distances were not brought into correct tonal balance until the development of new photographic techniques in 1873.[43] But in Düsseldorf, Hans Gude handled middle-distance hills in this manner. Moreover, such scenes of abrupt dark and light tonal contrast occur frequently on cloudy days. When one is in the wilderness, one is acutely aware of differences, and they help define spatial zones in an otherwise trackless and continuous expanse of hillside and mountain.

The type of organization used in *Thunderstorm* marked a new and significant compositional format for artists—and might help explain, for instance, the startling close-up lateral expanse of Frederick Church's *Niagara* (1857)—but it remains a mystery why artists did not exploit it more fully.

Oil on canvas, 19″ × 29″ (48 × 74 cm). Courtesy, Museum of Fine Arts, Boston.
Gift of Mrs. Edward Hall and Mrs. John Carroll Perkins.

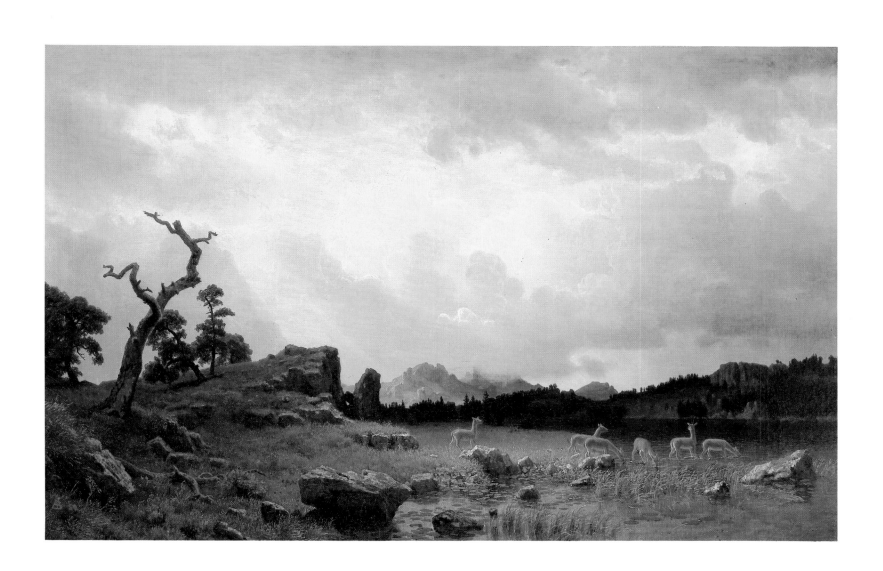

Plate 8

WIND RIVER COUNTRY
1860

In this painting we look over the foreground ridge toward a central valley flanked by trees and a mountain. Depth is halted, many miles distant, by the snow-covered mountain range. This compositional format, which Bierstadt used regularly, is a western variation of *Bernese Alps* (Plate 5). *Wind River* is one of the few works by Bierstadt in which the same family of colors dominates—yellows, oranges, and browns. The golden glow and relatively soft focus are reminiscent of the colors of the Roman *campagna*, but the lack of articulation of the painting's central area is an appropriate response to the desolate wastes of the American wilderness. In paintings such as this, Bierstadt did not paint the West as a Garden of Eden (which, after all, was a garden and supported human life) but as a pre-Edenic wilderness. Yet he did not turn the wilderness into a monstrous place in which all elements exist in adversarial relationships. Although the trees to the left are broken and the antelope has lost its life, we do not see the battles in progress. Bierstadt, who never alarmed his audience, however rugged or wild the vista, kept the bear at a safe distance and allowed it its meal, as if it were a dog contentedly gnawing a bone. (Studies for the bear and other animals are in one of the few surviving Bierstadt sketchbooks now in the Rutgers University Library.)[44] The artist might have added the genre element to indicate, in an inoffensive way, that wilderness has its own rules but that it is magnificent to behold, especially from a choice overlook.

Oil on canvas, 30" × 42½" (76 × 108 cm). Kennedy Galleries, Inc., New York.

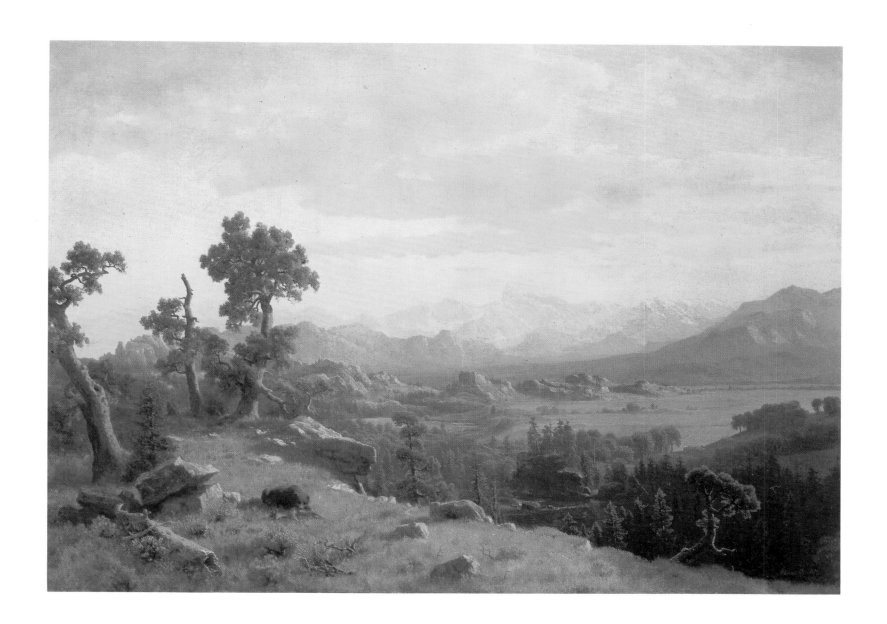

Plate 9

INDIAN ENCAMPMENT, SHOSHONE VILLAGE

1860

Although Bierstadt made probing studies of individual Indians during his travels in the West, he generalized their appearances and activities in his paintings. He placed them, as he placed European peasants in earlier works, in the middle distance so that we witness their presence in a landscape setting rather than focus on their movements. *Indian Encampment*, then, is the western equivalent of his European genre-ized landscapes and reveals Bierstadt's consistent attitude toward subject matter regardless of its locale. Here, between framing trees (a device he infrequently used), Indians are engaged in seemingly unrelated activities. At the left, a figure points with a stick. Women in front of the tepee are playing with a dog and perhaps, since dogs were an Indian delicacy, are cooking one inside. To the right, a woman with a papoose follows a man on horseback. The painting, bathed in a golden glow, suggests nostalgia for a previous age when Native Americans were thought to have lived harmoniously with nature. Here they are not wily, wicked, or predatory, but are engaged instead in peaceful domestic industry.

Works such as this are obviously part of the broad western European tradition of Arcadian scenes, but in its American version the tradition assumes a particular complexity and ambivalence.

Indian Encampment reveals the nobility of the Indians before their contact with Europeans and subsequent debasement. In time they would disappear, and for many, their disappearance was more important than their existence.[45] Paintings displaying this attitude were both pseudohistorical as well as fantasy-ridden in their reconstruction of Indian life. They undoubtedly provided the public with the images it wanted to see, especially during the years Indians were systematically being driven from their lands. Revealingly, many paintings of Indians of this period lack the documentary qualities of works by George Catlin (1796–1872) and Karl Bodmer (1809–93), painted when there was still ample space for everybody in the American West. These paintings also lack the viciousness of later works by Frederic Remington (1861–1909), done when Indians were being squeezed between new settlers and corporations exploring the mineral wealth of the land.[46]

In comparison with literary efforts, romanticized paintings such as this one might also be considered *retardataire*; the Indian, noble or otherwise, no longer engaged serious writers after the 1850s, and precise anthropological and linguistic analyses of Indian tribes were already being included in the Pacific railroad reports by that time.[47]

Oil on canvas mounted on board, 24" × 19" (61 × 48 cm).
The New-York Historical Society.

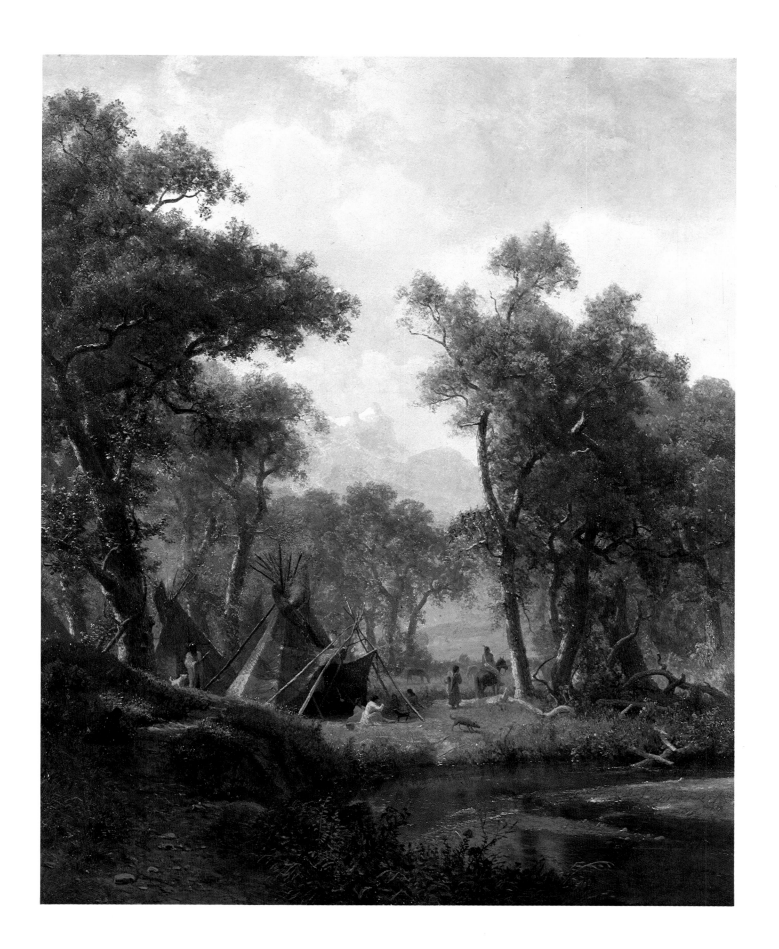

Plate 10

THE BOMBARDMENT OF FORT SUMTER

ca. 1863

In October 1861, Bierstadt and Emanuel Leutze, whom he had befriended in Düsseldorf, received a five-day pass from General Winfield Scott to visit Union troops near the Potomac River. (At about the same time, Bierstadt's brothers, Charles and Edward, were in the same area obtaining stereographs and photographs.) As a result of this trip, the artist painted *Guerrilla Warfare (Union Sharpshooters Firing on Confederates)* (1862). His interest in war scenes thus aroused, Bierstadt painted *The Bombardment*, with the aid of subsequent newspaper accounts, since he was not in Charleston on April 12, 1861, when the thirty-four-hour attack began. It is a shockingly quiet and serene painting, despite the puffs of smoke registering from the Confederate batteries. The view is taken from a point abruptly above the coastal plain, well out of hearing of the guns. Looking down at rather than over the scene, the viewer is some distance from the encircled fort.

The Bombardment is one of Bierstadt's earliest and most insistent panoramic views. The horizon line cuts the painting in half, and the sand spits and piers emphasize its lateral sprawl. The clarity of focus allies this work to *Gosnold at Cuttyhunk* (Plate 3), although the focus is somewhat obfuscated by Bierstadt's habits of allowing textures to thicken in the painting of trees and preventing the horizon line from growing translucent. It is as if scenes set on the Atlantic coast challenged his ability to create an ambiance as transparent as possible—he probably tried to capture the light of Long Island or the New England shore for *The Bombardment*. This is also one of Bierstadt's least structured works, the wrecked bunker in the foreground and Fort Sumter itself providing a needed vertical axis around which the arcs of shoreline sweep. The painting is profoundly topographical and secular in mood, although it is tempting to add transcendent meaning—the loveliness of the American earth and the clarity and purity of its air and spirit remaining despite the fratricidal conflict. It may have served as a model for another descriptive panorama completed later in the decade, Jasper Cropsey's *Narrows from Staten Island* (1868).

Oil on canvas, 26″ × 68″ (66 × 173 cm). Art Collection, Union League of Philadelphia.

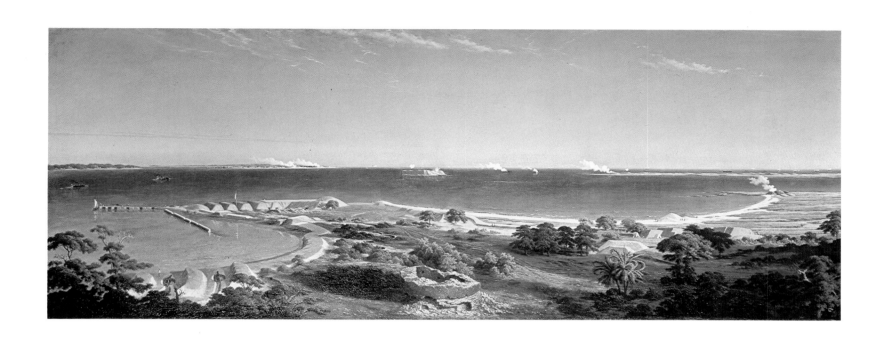

Plate 11

THE ROCKY MOUNTAINS

1863

This painting catapulted Bierstadt to national and international fame when it was exhibited at the New York Metropolitan Fair in April 1864. The purpose of the fair was to raise funds for the Sanitary Commission, the Civil War forerunner of the Red Cross. As part of the presentation, live Indians performed various activities, including ritual dances and sporting events.

The painting's immense popularity derived from the combination of its enormous size and its depiction of the gorgeous scenery of the Rockies. In the foreground, Indians go about their business unaware of the eavesdropping public. Behind, a transparent sheet of water reflects the enormous mountain range. The cumulative impact must have been thrilling to the urban eastern viewer. Here was the West of fantasy, a never-never land of savages and their sublime landscape, a wonderful place to think about visiting. No other civilized country could offer the prospect of experiencing such wilderness firsthand. On another level, this was not only a sublime landscape, but a landscape that symbolized America's imperial destiny—as if to say that the nation possessed more beautiful mountains, more open spaces, more clear air than any other.[48]

Compositionally, *The Rocky Mountains* is one of two basic types—the frontal and less common diagonal (see Plate 17)—that Bierstadt used for his larger wilderness views. Each had its own variations. This one is obviously the frontal type. The main lighted areas, in the middle and far distances, are centrally located. *The Rocky Mountains* is also traditionally organized in that land appears in the foreground, water in the middle distance, and mountains to the rear. Like the earlier *The Marina Piccola,* the painting is of the space-box type with the mountains, despite their awesome size, cutting us off from the sky. Unlike his Luminist contemporaries, Bierstadt controlled space rather than let it skip to infinity, suggesting an earthly-spiritual continuum.

The influence of photography is especially evident here: the clear foreground and misty background approximate the tonal intensities one would see in a stereograph view of such a scene. Because of the abrupt changes in tone, each major element in the painting seems to have come from a preassembled unit, thus creating a curiously static sequence of spaces.

Although this was the first popular panoramic western scene, others had preceded it, including views by Alfred Jacob Miller, based on his western trip of 1837; by John Mix Stanley and Charles Koppel, for the Pacific railroad surveys in the 1850s; by James Madison Alden, for the United States Coast Survey between 1854 and 1857 (which included views of Yosemite Valley by 1855); by George Douglas Brewerton, who exhibited western scenes at the National Academy of Design in 1854 and 1855; and by Thomas A. Ayres, who exhibited at the New York Art Union in 1857.[49]

Oil on canvas, 73½″ × 120¾″ (187 × 307 cm). Copyright © 1979 By The Metropolitan Museum of Art. Rogers Fund, 1907.

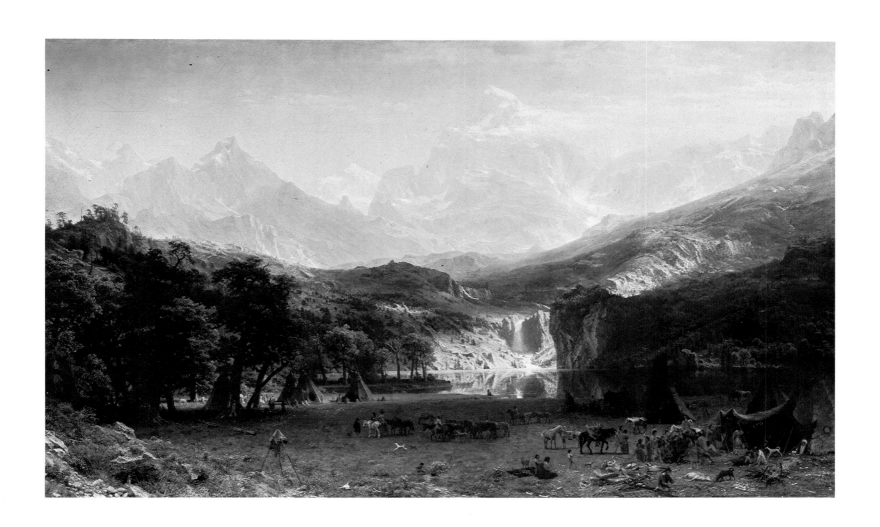

Plate 12

YOSEMITE VALLEY
1866

Bierstadt first visited the Yosemite Valley in 1863 and subsequently painted it in all seasons, climates, moods, and hours as well as in its several aspects—as a wondrous marvel and a pleasant park bordered by precipitously rising mountains, as an intimate place for a picnic or rest, and as a snow-covered desolate wilderness. He painted it in small and monumental scale, on small and enormous canvases. He was so charmed by the site that one historian has even conjectured that Bierstadt planned his second western trip only after seeing Carleton Watkins's photographs of the valley in Goupil's Gallery in New York City in 1862.[50]

This work shows Yosemite as a parklike enclosure, even though the valley floor was still wilderness. Despite threatening skies, the serenity of the view describes Yosemite's Edenic qualities. (Bierstadt usually preferred wilderness to garden scenes.) In fact, this is one of the artist's most harmoniously composed Yosemite scenes. The balances between forms and the continuities of movement (for example, from cliff profiles to tree trunks to reflections in the water) are studied more carefully than usual and point to the influence of Watkins. Even though Watkins, as a photographer, had less control over his subjects than a painter would have, he had the breathtaking ability to position his camera so that linkages between units and patterns of surface movement appear obvious and inevitable. He also attempted to restrict the number of forms and details in a scene, a characteristic that has a sympathetic echo in this work.

Oil on canvas, 40″ × 60″ (101.6 x 152.4 cm). Collection of Jo Ann and Julian Ganz, Jr.

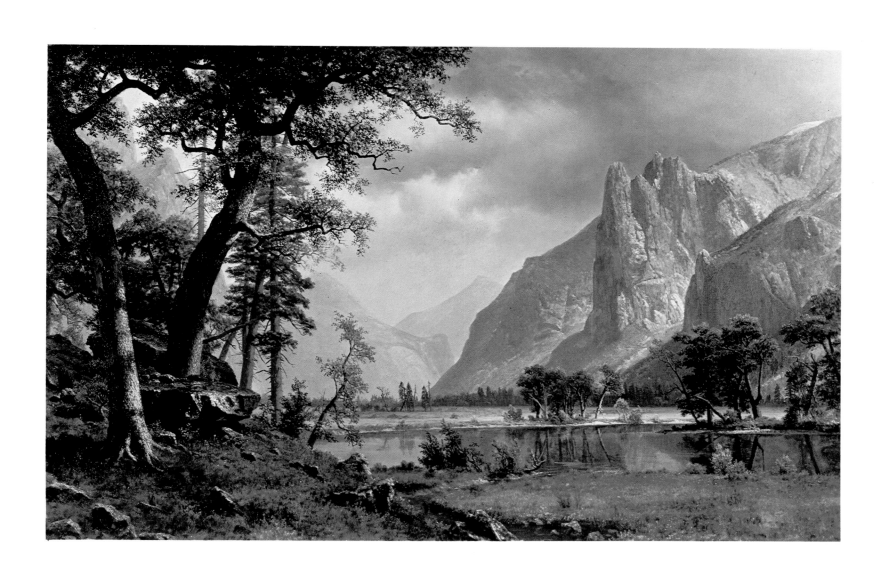

Plate 13

A STORM IN THE ROCKY MOUNTAINS, MT. ROSALIE

1866

Once thought to be lost, *A Storm*, the master-piece of Bierstadt's early career, was acquired by the Brooklyn Museum in 1976. Although the space-box format is used, the composition is quite unusual. Generally, Bierstadt balanced his large paintings by setting a central valley or body of water between flanking units of equal strength. But in *A Storm*, the mountains to the right obviously tower over those on the left, and in place of the standard valley floor and rising mountains, he created a complex sequence of elevations by adding an intermediate level in the foreground. To control the contrasts between solid mountains and open spaces, and between near and far distances, Bierstadt imposed a severe two-dimensional system of patterns that can be traced by following the connecting contours of objects, regardless of their position in depth. For instance, the left edges of the distant mountain in the center are visually continued along the edges of the clump of trees in the center foreground.

Landscape features and plant life are carefully studied in a manner quite different from the earlier *The Rocky Mountains* (Plate 11). Bierstadt added highlights in several colors to the large masses and varied the color scheme of the mountains much more subtly and intricately than before. But he also succumbed to his penchant for elaborating fantastic cloud formations hovering over the distant mountains, their rococo flourishes not always cohering visually with the generally descriptive style of painting. Nor do these clouds necessarily allow space to appear continuous from the foreground to infinity as in, for example, *View of Donner Lake, California* (Plate 19).

Bierstadt preferred keeping episodic elements to a minimum, but, consonant with the extravagant nature of *A Storm*, the results of an Indian hunt can be seen, horses are being chased, and an Indian encampment fills part of the valley. Never again would he paint such a complex and crowded work. *A Storm* is an attempt to show all at once the incredible beauty of the mountains; the vast western spaces; the phenomenal cloud formations; the variety of trees, bushes, and flowers; and a hint of the life-styles of the original inhabitants. The painting is truly a grand-scale celebration of the American West.

Oil on canvas, 83" × 142¼" (210.8 × 361.3 cm). The Brooklyn Museum, Dick S. Ramsay Fund, A. Augustus Healy Fund B, Frank L. Babbott Fund, A. Augustus Healy Fund, Ella C. Woodward Memorial Funds, Gift of Daniel M. Kelly, Gift of Charles Simon, Charles Smith Memorial Fund, Caroline Pratt Fund, Frederick Loeser Fund, Augustus Graham School of Design Fund, Bequest of Mrs. William T. Brewster, Gift of Mrs. W. Woodward Phelps, Gift of Seymour Barnard, Charles Stuart Smith Fund, Bequest of Laura L. Barnes, Gift of J.A.H. Bell, John B. Woodward Memorial Fund, Bequest of Mark Finley.

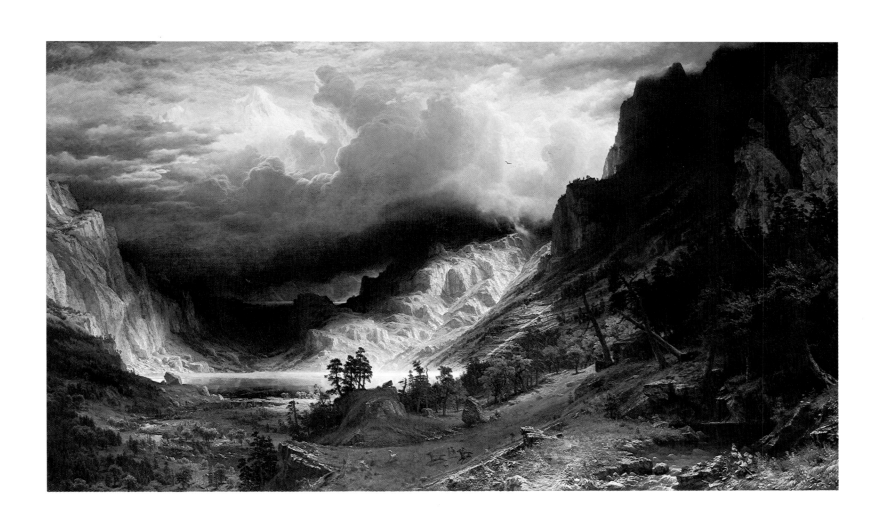

Plate 14

IN THE MOUNTAINS
1867

The vista Bierstadt painted here is one of terrifying isolation—a mountain stream or lake bordered on one side by cliffs with a steep rise of several hundred feet and on the other by traversable land stopped to the rear by the wall of a giant cloud-covered mountain range. Perhaps a storm has just passed. But so cleverly has Bierstadt enclosed the water in a typical space-box format, reduced the cliffs on the left to the height of the balancing trees on the other side of the water, given the mountains a clean and airy rather than a menacing aspect, and provided us with a relatively small and safe area of land to walk on in the lower right, that we only look at the visually sublime view rather than feel the intense physical solitude. The wilderness is not frightening but rather seems benign, pure, and innocent. Bierstadt achieves this effect in part by hiding the vast amount of space between the viewer and the most distant waterfall. The foreground ends with the trees that jut out

into the water from either bank; then the background starts abruptly. A long and deep middle distance is simply eliminated; the background, despite the enormous vista, becomes the middle ground. Spatial recession appears to stop at the rear of the foreground, and the mountainous distance appears as a harmless drop cloth. With such devices Bierstadt made the western mountains domestic in scale, thus easy to live with in one's sitting room. He might also have wanted to paint a sublime view almost as if it were a harmonious and picturesque scene to impress his European audiences. Possibly, *In the Mountains* was painted during his two-year stay abroad. The format was evidently a successful one, for it was repeated several times: in *Landscape* (1868, Fogg Museum, Cambridge, Massachusetts), *Sierra Nevada Morning* (1870, Thomas Gilcrease Institute, Tulsa), and *Mountain Lake* (n.d., Joslyn Art Museum, Omaha).

Oil on canvas, 35⅜" × 49⅝" (90 × 126 cm). Wadsworth Atheneum, Hartford, Connecticut.

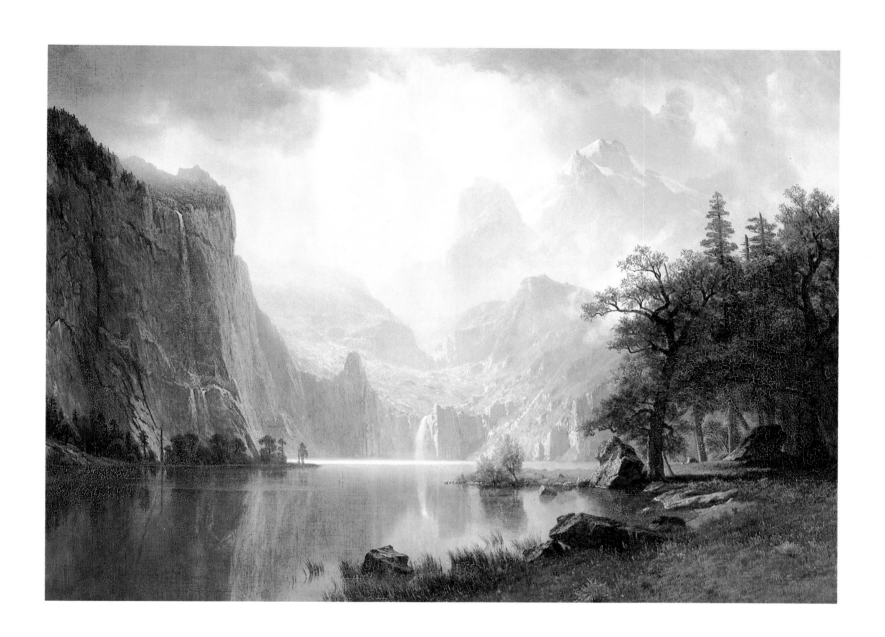

Plate 15

THE BUFFALO TRAIL

1867-68

The *Buffalo Trail* was probably painted abroad. Perhaps to make the West less strange to would-be purchasers, Bierstadt turned the plains into a vast English park and bathed the scene in a romantic moonlit glow. The line of buffalo stretches to infinity; the animals parade in dignified single file past the viewer. Despite the seeming artificiality of the scene, Bierstadt might have witnessed a panorama similar to this. Evidently, humans could hide within fifteen to twenty yards of the trails that buffalo invariably followed to watering places, of which many were only a few feet deep.[51]

The Buffalo Trail also reveals Bierstadt's developed sense of composition; to him the canvas was an organizational whole, whereas several of his contemporaries took the attitude that it was a surface to be covered with additive elements. Here, the oval dip of the pond is echoed by the rising oval of the cloud bank. The directional movement and dark colors of the large central cloud bank link it compositionally to the clump of trees to the right.

The emphatic shadows of trees in the water help tie the lower and upper parts together. These devices, more obvious here than was usual, indicate that Bierstadt had been studying European landscapes intently. The way he used the hidden light source, a motif with which he was already familiar, suggests a study of Turner's paintings.

Bierstadt apparently found night scenes to his liking, for he painted several of them and imbued them with a sense of nature's own life and living presence. Whereas daylight scenes often seem a collection of surfaces, the night landscapes reveal nature's soul. This quality is derived from the loss of detail and the suggestion of humid, thickened air such as can be experienced on the plains at night. The mood is elegiac rather than mysterious or brooding. Bierstadt has nicely combined realistic elements with obvious pictorial conventions, creating a painting that neither shows the plains as they actually appear nor lays an artificial gloss on American scenery.

Oil on canvas, 32" × 48" (81 × 122 cm). Courtesy, Museum of Fine Arts, Boston. M. and M. Karolik Collection.

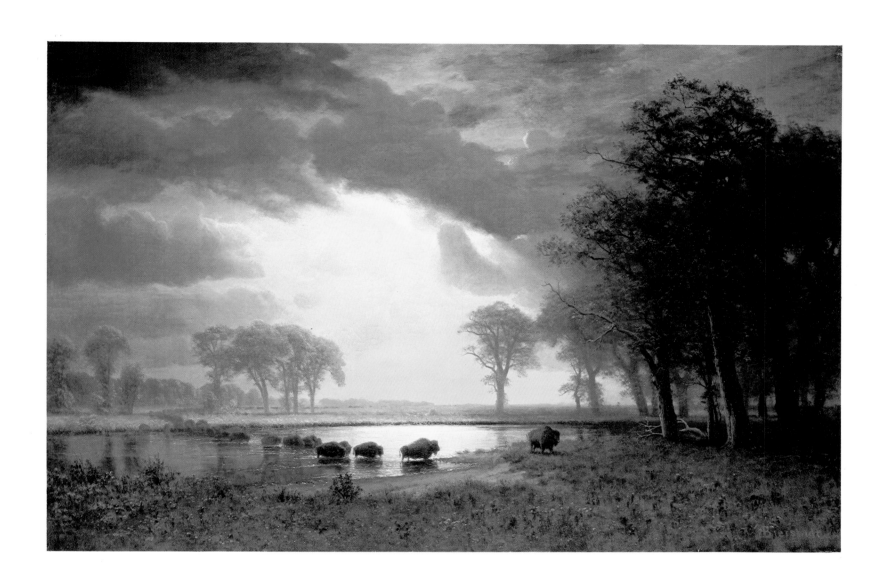

Plate 16

THE OREGON TRAIL

1869

During the westward leg of his 1863 trip to California, Bierstadt and his traveling companion, Fitz Hugh Ludlow, saw a wagon train bound for Oregon. Like other writers, Ludlow carefully reported the scene in his book *The Heart of the Continent*.[52] To his credit, Bierstadt did not paint the caravan as a detailed genre scene but instead sought the general flavor of the westward migration. His portrayal is similar to William Gilpin's description in 1846. Written when the idea of Manifest Destiny was especially powerful, Gilpin's account idolized and idealized the pioneer family: "Surrounded by his wife and children, equipped with wagon, ox-team and provisions, such as the chase does not furnish, accompanied by his rifle and slender outfit of worldly goods, did these hardy men embark upon the unmeasured waste before them."[53]

Bierstadt's American landscape includes forest, dry land, and mountain terrain through which a wagon train proceeds at a measured, unhurried pace. Water appears on the trail to quench the thirst of man and animal, assuring the pioneers of their survival and that of their flocks, as well as of their dreams of putting down roots in the new land. Onward they move under a beautiful sky. The new land shimmers, still hidden in the haze of tomorrow, and we know that all is serene and success is predestined, as if a benevolent hand were guiding the caravan through the idealized American landscape. In paintings of this type, one assumes that the artist suffused the land with religious sentiment and the settlers with holy mission. This reflects the view that whites in America, especially Anglo-Saxons, were thought to be carrying out God's will. One contemporary author, after damning the Indians for not leaving their mark upon the continent and for neglecting to contribute anything to the development of mankind, asked the question Why emigration? The answer was, simply, "It is the law of God. The world must be occupied and subdued, and civilized man must occupy and subdue it."[54]

By describing the general aspect of the wagon train rather than a specific anecdote about a single group of pioneers, Bierstadt brilliantly captured the ideals of Manifest Destiny. Certainly, this painting more effectively outlines the combination of religiosity, determination, expansionism, and self-righteousness of the concept than the more famous and falsely theatrical *Westward the Course of Empire* (1861) by Emanuel Leutze.

Oil on canvas, 31″ × 49″ (79 × 124 cm). The Butler Institute of American Art, Youngstown, Ohio.

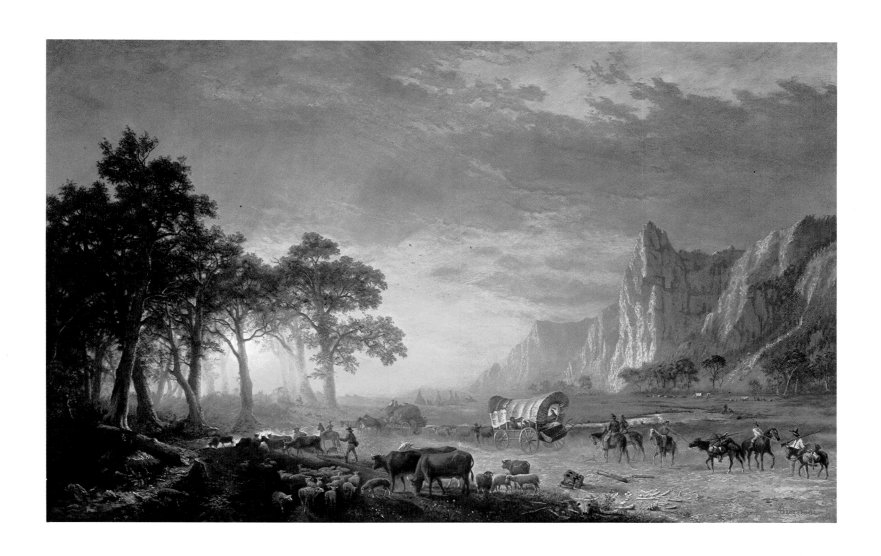

Plate 17

SUNSET IN THE YOSEMITE VALLEY

1869

Painted in England, *Sunset* is one of Bierstadt's most dramatic interpretations of the Yosemite Valley. It combines a turbulent sky with an absolutely still valley floor and glassy, flat river. Possibly, he exaggerated the drama of a Yosemite sunset to impress his English audience, but it is more than likely that Bierstadt painted a true portrait of the scene. (Jasper Cropsey's colorful *Autumn on the Hudson* [1860] was disbelieved until the artist produced some dried leaves!) In 1872, a few years after *Sunset* was made, Clarence King described a similar sunset: "At this hour, there is no more splendid contrast of light and shade than one sees upon the western gateway itself—dark shadowed Capitan upon one side profiled against the sunset sky, and the yellow mass of Cathedral Rocks rising opposite in full light, while the valley is equally divided between sunshine and shade. Pine groves and oaks, almost black in shadow, are brightened up to clear red-browns where they pass out upon the lighted plain." Describing another similar scene, King saw "a soft aerial depth of purple tone. . . . Over it all, even through the dark sky overhead, there seemed to be poured some absolute color, some purple air, hiding details, and veiling with its soft amethystine obscurity all that hard broken roughness of the Sentinel Cliffs."[55]

The blurring radiance of the sun reveals Turner's influence, but Bierstadt did not allow the translucent waves of light to reach out to all parts of the painting. In fact, he might even have been discomfited by Turner's softer style. Bierstadt's clouds, floating above the tunnel of sunlight, are surprisingly detailed and imbued with physical substance. The trees in the lower left, even though no longer directly receiving the sun's rays, throw up a virtual solid wall of green through which no gold can penetrate. The edges of the trees neither yield nor melt, preventing the golden light from suffusing all the objects and the air of the valley. Perhaps works such as this prompted criticism of Bierstadt's art and Düsseldorf painting in general. The details are all there, but a single informing spirit does not inhabit the canvas. Instead of becoming inspirational, the work remains topographical and theatrical.[56]

Oil on canvas, 35¾" × 52" (91 × 132 cm). Haggin Collection. Pioneer Museum & Haggin Galleries, Stockton, California.

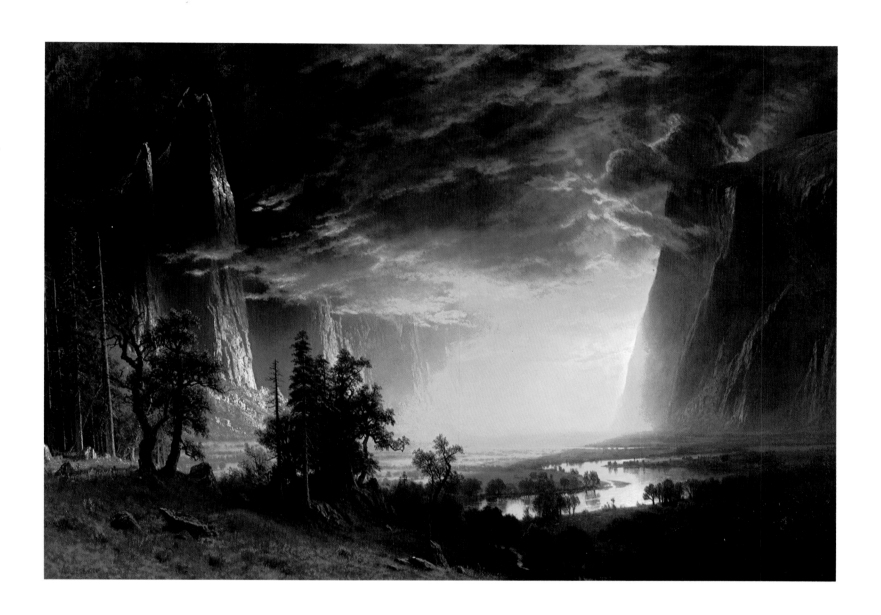

Plate 18

SIERRA NEVADA
(FROM THE HEAD OF THE CARSON RIVER)
1872

This large sketch is one of the most interesting products of Bierstadt's various forays into the mountain wilderness, done during his third trip to California, which lasted from 1871 to 1873. Bierstadt traveled in the Sierras with a variety of people, including Collis P. Huntington, the railroad magnate, and Clarence King, the geologist.

In larger and more polished works of mountain scenes, Bierstadt balanced the mountains around a central valley or body of water or placed a mountain in the center and emphasized its centrality by suppressing forms at the peripheries. But this view approximates the initial visual impact of a wild mountain area. From a high vantage point we see an endless, trackless wilderness. Even with the obvious centrally crossing diagonals of the mountain profiles, there is neither a central focus nor framing elements at the sides. The mountains in the distance extend beyond the picture space, and the foreground peak rises from the unseen valley floor. We seem to float somewhere in a directionless space. There is no place truly to anchor ourselves or to measure ourselves against the land and control it. Like the earlier *Surveyor's Wagon in the Rockies* (Plate 6), this work indicates disorientation in a totally uncivilized landscape. Of contemporary photographers only William Henry Jackson dared to photograph mountains in this manner, another indication of the similarity of vision of these two artists.[57]

Sierra Nevada also reveals an aspect of Bierstadt's compositional interests that was repressed in his large works—his ability to think in terms of abstract relationships of form. This ability is demonstrated in many of his small studies, such as *Finsterhorn* (Figure 2), which are comparable to the works of only a few nineteenth-century artists, notably John Twachtman (1853–1902).

Oil on board, 14" × 19" (36 × 48 cm). Photograph courtesy of Graham Gallery, New York.

Plate 19

VIEW OF DONNER LAKE, CALIFORNIA
1873

Commissioned by Collis P. Huntington in 1871, *View of Donner Lake* shows the terrain over which he built his Central Pacific Railroad. Snow sheds covering the tracks appear on the right slope above the lake. Bierstadt painted one of his most desolate wilderness scenes perhaps to emphasize the difficulties of building a railroad through the highest pass the Central Pacific would span. The large trunk on the ground is used compositionally, pointing into the picture space to suggest depth. Branches are strewn over the landscape, and dead trees, still standing in the foreground, indicate the problems of survival at such altitudes.

The vista Bierstadt painted is a grand one, however. Many of his best mountain scenes date from this period, and *View of Donner Lake* is one of the more successful of them. We look across the lake and down on cloud banks to a range of mountains in the distance. Like the earlier *Bernese Alps, as Seen near Kusmach* (Plate 5), *View of Donner Lake* is painted from an elevated position, but by the 1870s Bierstadt had developed a much firmer control over spatial recession. He handled atmospheric gradations and topographic recessions with logical consistency, from the more sharply focused forms on the slopes in the foreground to the mountains almost lost in the haze. This is true even of the dark ridge at the left, reminiscent of landscape photography as well as of the paintings of Hans Gude. Bierstadt's tendency to use a space-box formulation is here kept under tight control. The lake and the small pond just before the dark ridge glisten and reflect appropriate amounts of light. Bierstadt cleverly used the rolling mountainsides to provide diagonals linking opposite sides of the lake. The clump of trees to the left, a Düsseldorfian motif, both sets off and balances the cliffs on the right.

Unlike *Bernese Alps*, no genre elements inhabit the vast spaces of *View of Donner Lake*. Virtually without exception, Bierstadt eliminated Indians and animals from his mountainscapes after the late 1860s. He preferred instead to let nature celebrate itself alone rather than to show how humans or animals live in nature or in harmony with it. One senses in this work and others of these years a self-confidence and a maturing ability to integrate influences, photographic and otherwise, into a consistent style. On the other hand, Bierstadt also painted mountainscapes through these years with another sensibility. In some, clouds boil up from and around improbably high mountains, as in *A Storm in the Rocky Mountains* (Plate 13). In others, two paintings appear to be joined as one, as in *The Rocky Mountains* (Plate 11). Perhaps Bierstadt used these earlier formats when inventing scenes rather than portraying specific places such as Donner Lake. In any event, his different approaches exist simultaneously and seem not to follow any chronological pattern.

Oil on canvas, 72" × 120" (183 × 305 cm). The New-York Historical Society, Gift of Archer Milton Huntington.

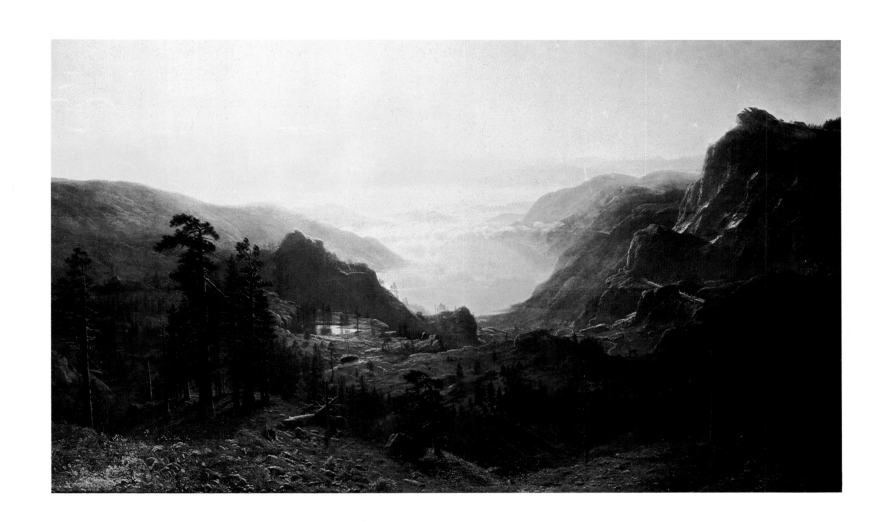

Plate 20

SEAL ROCK

1873 or 1875

In April 1872 Bierstadt visited the uninhabited Farallon Islands, about twenty miles from San Francisco, and produced at least two finished paintings of island scenes.[58] In this one he turned an animal painting into a genre study. The seals swim, eat, lecture their children, gossip, and sleep. The large central rock as well as the large wave and the distant bird-covered cliff look suspiciously like mountains, but each has a color and texture appropriate to its substance and position in space. The proximity of the rock to the picture plane reveals Bierstadt's method of building up large, solid masses by small touches of color, a painstaking procedure in the larger landscapes.

Although *Seal Rock* was obviously painted from studies, Bierstadt captured to an extraordinary degree the peculiar volatility of the air on and off the California coast. When painting the rock itself, he caught with great accuracy the mixture of thin fog and sea foam that allows forms in the foreground to appear sunlit but blurs and makes mysterious objects a few feet distant. In the background he also observed correctly the opaque tongue of fog that seems to belong to a different weather system, already obscuring the base of the distant cliff. One imagines that if Bierstadt had been less attracted to mountains and their dramatic weather patterns, he might have become a brilliant recorder of the constantly changing climate of the California coast. His keen sense of perception is not unexpected in a work such as this. *Seal Rock* is a middle-sized painting, and when Bierstadt worked in this and in smaller sizes, he proved to be a sensitive recorder of light effects, more versatile, if less subtle, than the contemporary Luminists (see Plates 3 and 26). Light, California light, is crucial to the content of the painting. Thus, one might say that *Seal Rock* is an example of West Coast Luminism, even though its drama and sense of movement are entirely different from the serene qualities of its eastern counterpart.

Oil on canvas, 30" × 45" (76 × 114 cm). From the collection of the New Britain Museum of American Art, Alix W. Stanley Fund.

Plate 21

THE AMBUSH

1876

Thought to have been painted in the 1870s, *The Ambush* is perhaps Bierstadt's most mysterious work. Actually, it appears to describe a double ambush. Indians are attacking a wagon while soldiers in Union blue lie in wait, rifles at the ready. A wagon train is in the distance. Several questions need to be answered immediately. Why has the wagon left the train? Were the soldiers waiting to ambush the train, only to be preempted by the Indians? Who are the renegades here?

The catalog of the Karolik Collection states that the scene is set in the Wind River country in Wyoming, but the foliage appears too lush for that part of the West.[59] The painting is also unusual among Bierstadt's genre scenes in that he usually incorporated the subject into the landscape instead of emphasizing the subject so obviously. In addition, he rarely animated a scene with such drama. Nor did he usually paint the conflict between whites and Indians in this anecdotal fashion. In another ambush scene, *Guerrilla Warfare*, which he did in 1862 after touring Union positions near the Potomac River, Bierstadt characteristically showed troops, their backs to the viewer, firing at the enemy in the distance. Despite its theme, *Guerrilla Warfare* is surprisingly sedate and nonfocused. Perhaps *The Ambush* was completed in England to show a colorful American scene to appreciative Europeans, or perhaps it was based on a scene in a novel or short story.

Oil on canvas, 30″ × 50″ (76 × 127 cm). Courtesy, Museum of Fine Arts, Boston. M. and M. Karolik Collection.

Plate 22

MOOSE HUNTERS' CAMP, NOVA SCOTIA

Ca. 1880

Bierstadt was a compulsive traveler, visiting Europe, Canada, and the West repeatedly. Sometimes he traveled in luxury; at other times he camped out or stayed in relatively spartan quarters. On occasion he accompanied the rich and powerful, including the Earl of Dunraven, who in 1876 had acquired most of what became Estes Park in Colorado. Bierstadt was especially friendly with two governors-general of Canada, the Marquess of Dufferin, whom he met in 1874, and the Marquess of Lorne, Queen Victoria's son-in-law, whom he met in 1880. Bierstadt, also an inveterate sportsman, is known to have spent part of June 1881 fishing on the Gaspé Peninsula in Canada with Lorne. Perhaps *Moose Hunters' Camp* commemorates an earlier excursion to Nova Scotia in 1880 when Bierstadt killed a moose that had what was then the eighth-largest known set of antlers in the world.

In this work the wilderness is a benign presence, a place to visit to escape from the workaday world. The hunters will eat their catch, but they hunt for sport, not survival. Although the woods are certainly more remote than Adirondack and Maine forests, there is no sense of the menace that characterizes similar scenes by Winslow Homer (1836–1910). Nor is *Moose Hunters' Camp* a nostalgic picture of a less complicated earlier time, as Eastman Johnson painted during those years. Rather, it is a vacation picture, one of the few Bierstadt painted.

One senses in this work both the coziness of an intimate scene and the comprehensiveness of a broadly viewed landscape, qualities Bierstadt was able to inject into his medium-size paintings (Plate 24), especially around 1880. At that time he experimented with brushy textures and sketchlike details, most notably in works probably recording his hunting trip to Nova Scotia. No doubt he was responding to the new, more painterly styles of Munich and Barbizon then being introduced into America. Evidently works of this type did not suit his artistic personality, since he never became an intimist, nor did he abandon his relish for precise detail. Yet his later work is more loosely rendered, and on occasion he seemed to try to accommodate his large mountainscapes to the new taste (Plate 28).

Oil on canvas, 26½" × 36½" (67 × 93 cm). Courtesy, Museum of Fine Arts, Boston. M. and M. Karolik Collection.

Plate 23

LOWER YELLOWSTONE FALLS

1881

Although Bierstadt had traveled to the West several times in the 1860s and 1870s, he did not visit the Yellowstone area until 1880. Of the varied scenery he saw there, he was most attracted to the geysers and Yellowstone Falls. His finished paintings tended to be medium-sized, indicating that he was not as attracted to the area as Thomas Moran. Or perhaps he chose not to compete with Moran, whose famous *Grand Canyon of the Yellowstone* was completed in 1872. Bierstadt's *Lower Yellowstone Falls* was probably based on his own sketches and the photographs of William Henry Jackson (Figure 5). In his version, Bierstadt provided the falls with greater vertical lift by steepening the diagonals of the canyon and accenting the cliff at the upper right. He also raised the horizon line nearly to the top of the painting, a device used by American painters at least by the 1850s. In the foreground Bierstadt placed a few trees, a device Hans Gude had used in Düsseldorf, to provide a sense of distance between the viewer and the falls. Except for these few alterations, including the emphasized crossed diagonals in the center and the profile of the lower rocks echoing the contour of the lip of the falls, the painting is an unaffected exercise in realistic depiction. A larger painting, undoubtedly based on this study, is another matter (Figure 6). There, violent contrasts of dark and light throw the foreground trees into theatrical, as opposed to merely dramatic, relief. The cliffs assume a candy-coated quality. Additional and exaggerated amounts of foam lather up from the base of the falls, and the mountain in the distance detracts from the central compositional climax of the falls themselves. Clearly, the smaller study appeals more to our contemporary taste, and it probably appealed to the informed taste of 1881 as well.

Oil on paper, mounted on canvas, 19¼" × 13½" (49 × 34 cm). The University of Georgia, Georgia Museum of Art, Eva Underhill Holbrook Memorial Collection of American Art. Gift of Alfred H. Holbrook, 1945. Photo by William G. Murray.

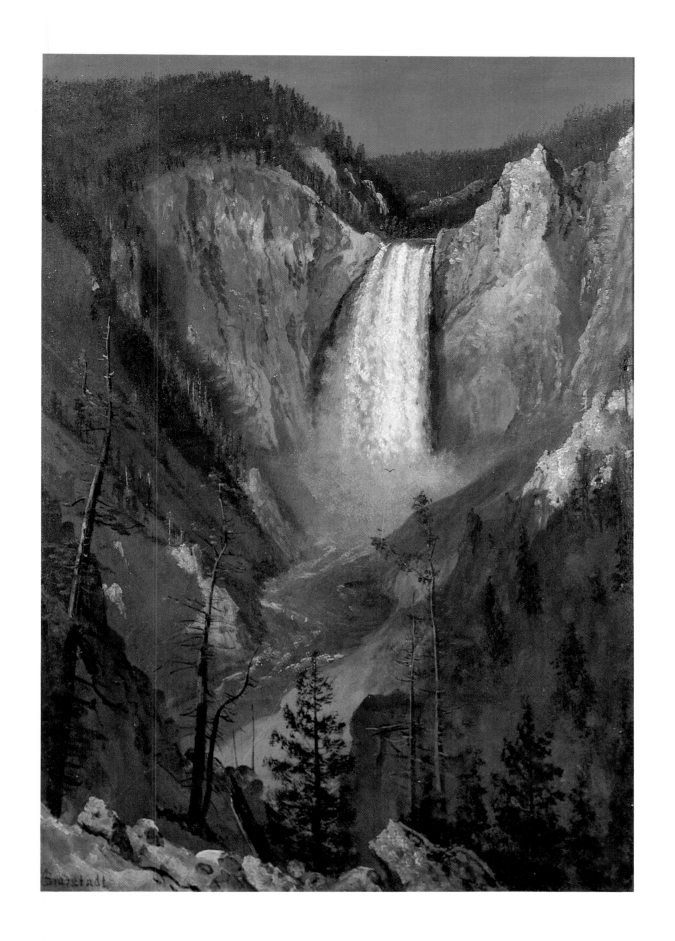

Plate 24

AUTUMN WOODS

1886

Autumn Woods is one of several similar paintings Bierstadt completed between the early 1860s and late 1880s. The general format of these peaceful scenes is a parklike area, neither cultivated nor entirely wild, with a pool of water or a glade in the center. A lateral expansiveness pervades these works because they often lack framing trees. The seasons depicted are summer or autumn. There might be wild animals or, more rarely, humans, usually resting. Light filters through the trees toward the viewer, but occasionally the sun lies over one's shoulders and reaches into the painting. In either instance, air seems to penetrate the forest thickets, and even in dark places air seems to surround objects, an unusual feature in Bierstadt's work.

Of all his paintings, these are the most space-filled and spatially consistent, in part because they encompass less land than the more broadly scaled mountain scenes. It was simply easier to indicate recessions around trees and over small rises in the land without having to worry about relating these elements to ranges of distant mountains. These paintings are also among his most Edenic—pleasant and beautiful and habitable rather than sublime and savage. All of them convey qualities of shelter and peace. As a group, they are closest to Luminism, but Bierstadt's brush strokes remain distinct and he uses a wider range of tonal contrasts. The dark areas are also darker than one normally finds in Luminist works. (Bierstadt's paintings on this theme are space-filled rather than light-filled.) Many are of eastern scenes, although it is not always possible to determine their specific locales.

Oil on canvas, 54″ × 84″ (137 × 213 cm). The New-York Historical Society.

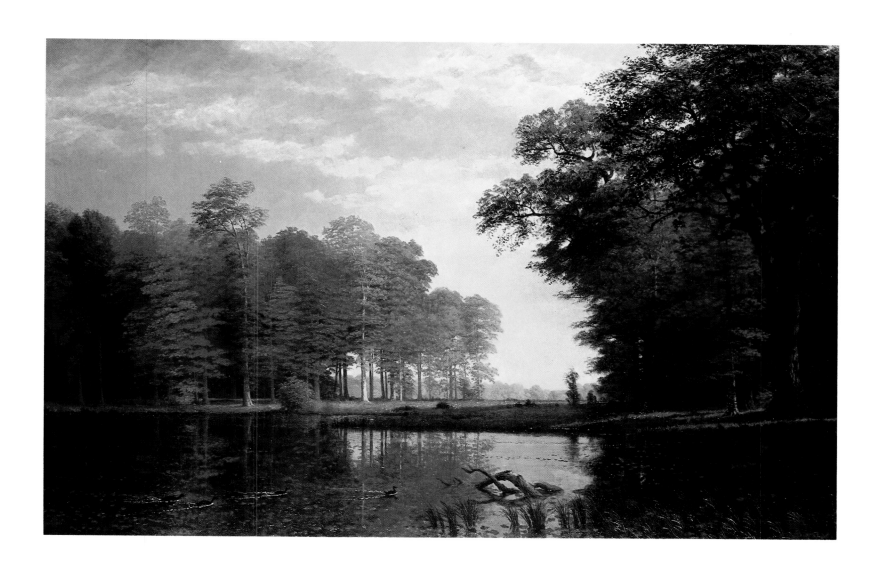

Plate 25

THE LAST OF THE BUFFALO

1888

One of Bierstadt's large, late paintings, *The Last of the Buffalo* was rejected by the American screening committee for inclusion in the Paris Exposition of 1889, but Bierstadt, exercising his privilege as a previous medalist of the French Academy, sent the picture anyway. If the picture were simply called *The Buffalo Hunt*, we might think of it as a nostalgic remembrance of the vast buffalo herds Bierstadt saw in the 1860s. The skulls in the foreground could be easily explained because of their proximity to water, where so many buffalo were killed. One might also want to read the bones symbolically as recording the passing of a way of life for both the Indians and the buffalo.[60] The actual title, *The Last of the Buffalo*, helps make this reading plausible.

But the title as well as Bierstadt's explanation of the painting confuse one's understanding of the work. Bierstadt said that he had "endeavored to show the buffalo in all his aspects and depict the cruel slaughter of a noble animal now almost extinct."[61] If this were indeed the last of the buffalo, how can we account for the incredibly large herd that recedes back into the broad valley until it merges with the landscape? But, more important, the painting is a misreading of the facts. The Indians did not cruelly slaughter buffalo, nor did they cause its near extinction. Unlike whites, they did not kill for sport. (On one occasion Bierstadt helped organize a buffalo hunt for the Grand Duke Alexis of Russia.)[62] Rather, Bierstadt put a palatable romantic gloss over the scene by ignoring the true reasons for the passing of the buffalo as well as the Indian. Instead of showing the actions of the whites, he painted a diversion—two minority groups, as it were, contending with each other to the death. We wonder if the Indian on the white horse will kill the buffalo before the latter gores the horse. We thrill to the old and now rapidly passing days of the frontier West when brute man fought brute animal. The painting is, in effect, a whitewash of history of the sort that became popular late in the century, especially in the works of artists such as Frederic Remington.

The painting is in one of Bierstadt's traditional formats. The action occurs in the foreground, here a shallower stage than usual, and the rear spaces behind the fox in the left center appear separate from rather than continuous with the foreground. Yet, a broad spaciousness pervades the middle and far distances. Bierstadt daringly placed a single buffalo on the left whose intense gaze and momentarily controlled power counterbalance the greater activity and number of buffalo on the right. In another version of the painting in the Buffalo Bill Historical Center, the Whitney Gallery of Western Art, Cody, Wyoming, the absence of the single buffalo changes the nature of the painting considerably.

Oil on canvas, 71¼″ × 119¼″ (181 × 303 cm). In the collection of the
Corcoran Gallery of Art, Gift of Mrs. Albert Bierstadt.

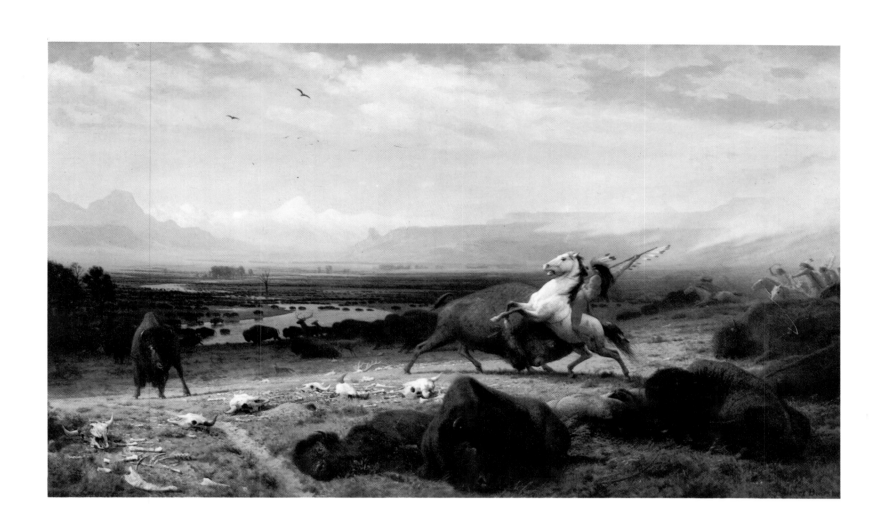

Plate 26

WRECK OF THE "ANCON" IN LORING BAY, ALASKA
1889

On one of his several trips to the Northwest, Bierstadt was aboard the *Ancon* when it ran aground in Loring Bay. Either from the shore or from another boat, Bierstadt painted this small study of the ship and the surrounding bay, which reveals the characteristic subtlety of his sketching technique, in which he thinned pigment almost to watercolor consistency, and his acute sensitivity to light, here the fogged light of the Pacific coast. Bierstadt exhibited equally subtle responses to coloristic and tonal changes as well as to lighting conditions in his many studies of animals. He did not paint such scenes by rote, but studied each one as if seen for the first time. In *Wreck* the gray of the sky and of the water is continuous, destroying, especially to the right of the boat, any possible reading of recessive space. Yet in other small works, Bierstadt recorded layers of atmospheric haze reaching to infinity. Probably no other American artist so keenly investigated the different lighting conditions of the country—the peculiar clarity of the New England shore (Plate 3), the unmeasureable distances of the plains (Plate 6), the mist-ridden sunlight of the California coast (Plate 20), the barely perceptible atmospheric changes in mountain country (Plate 19), or, as in *Wreck*, the effects of northwestern fog on one's perceptions. If we could ignore some of Bierstadt's most theatrical paintings, he would emerge as one of the most versatile and skillful painters of American light in a period of intense concern with its properties. *Wreck* is also interesting compositionally in that only the utmost delicacy of tonal manipulation prevents the boat from slipping from its assigned location in space since there is no traditional foreground.

Oil on paper mounted on panel, 14" × 19¾" (36 × 50 cm).
Courtesy, Museum of Fine Arts, Boston. M and M. Karolik Collection.

Plate 27

THE LANDING OF COLUMBUS

1893

Bierstadt painted at least three versions of this subject, one of which was intended for the World's Columbian Exposition in Chicago in 1893. (One purpose of the Exposition was to celebrate the four-hundredth anniversary of the Europeans' discovery of the Western Hemisphere.) The version Bierstadt might have submitted—his largest painting, measuring 108 by 204 inches (274 by 518 cm)—was destroyed in 1960. A third version belongs to the Newark (New Jersey) Museum. All three are basically the same in general design, and although Bierstadt sought accurate detail in the type of beach on which Columbus landed and in the dress worn by the Indians he met, the paintings resemble the overall layout of his *Discovery of the Hudson* (1875, U.S. Capitol).

On a sandy inlet, the landing party is met by Indians gathered near the shore. A key difference among the paintings, river view in one and ocean views in the others aside, is the activities of the Indians. In the earliest work, Indian leaders offer a peace pipe to the explorers. In the later paintings, several Indians have rushed to the beach to prostrate themselves before the Europeans. Peaceful accommodation has been replaced by colonialism, since the Indians kneeling before Columbus somehow know that a superior culture, to which they give instant homage, has just landed. The sun of the new day shines on the Europeans, while the Indians, who may never become enlightened, live in shadow.

It is perhaps not a coincidence that the question of colonial expansion then occupied the nation, particularly in regard to the Hawaiian Islands.[63]

Previously, territory was admitted to the nation if it was governed by people—white, preferably Anglo-Saxon—capable of becoming full partners and sharing in the American democratic experiment. Lands governed by nonwhites were excluded. But at the end of the century, the possibility arose of annexing land as colonial dependencies. The Republican administration of Benjamin Harrison (1889–93) favored such a policy; Grover Cleveland's Democratic administration (1893–97) did not. Bierstadt seems to have been acquainted with Cleveland personally,[64] but we do not know precisely his thoughts on annexation or race.

The evidence drawn from his paintings is inconclusive, although in the case of *The Landing* utterly damning. The painting is a blatant artistic statement in support of colonial expansion and white superiority. Columbus, acting as a surrogate for expansionist America, is welcomed by an inferior and subservient race willing and eager to serve its future masters. The painting does not show the finer side of Manifest Destiny, of the American sense of mission, of setting an example of moral responsibility and selfless devotion, but rather its most crass form—territorial acquisition and subordination of native populations. This aspect of Manifest Destiny dovetails with contemporary concepts of racism that were rehashed in both anthropological and religious tracts.[65] Probably for reasons related more to Bierstadt's now old-fashioned style rather than to his modern theme, *The Landing*, submitted to the jury of the World's Columbian Exposition, was rejected for hanging.

Oil on canvas, 80″ × 120″ (203 × 305 cm). The City of Plainfield, New Jersey.

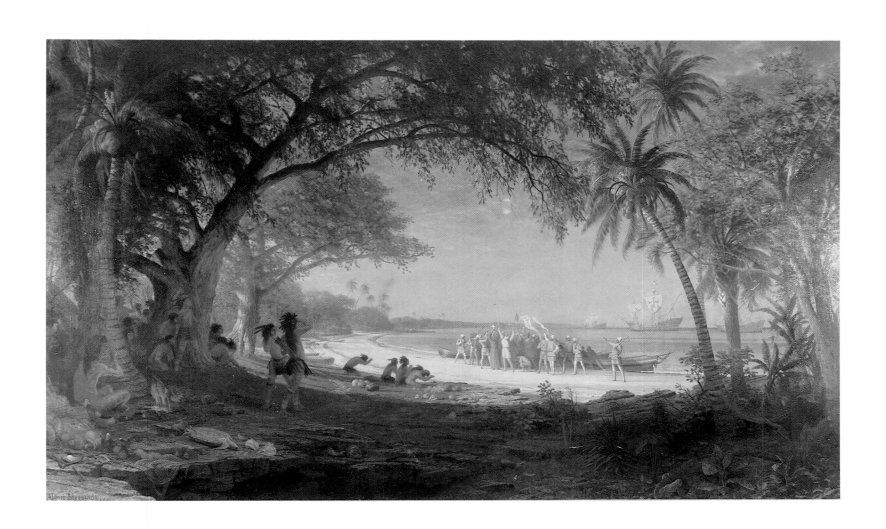

Plate 28

THE MORTERATSCH GLACIER,
UPPER ENGADINE VALLEY, PONTRESINA

1895

Painted probably just after a trip abroad in 1895, *The Morteratsch Glacier* is one of Bierstadt's last large paintings. It reveals the increasing looseness of his brush strokes, especially in his portrayal of ground cover. The bands on the near mountainside are a reversion to a type of brushy finish he used three decades earlier in *The Rocky Mountains* (Plate 11). In the intervening years he often painted such bands in meticulous detail. The overall composition indicates, as well, that Bierstadt, who painted dozens of mountainscapes, did not always repeat himself by rote. In place of a centrally recessive valley, a clump of Düsseldorf-style trees deflects the flow of space to the left along the valley floor. The shaft of light rising up the face of the mountain compensates for the leftward direction of the valley. The fallen trunk to the left points out from rather than into the picture, a reversal of Bierstadt's usual practice, which opens up the space. Because space is diffused to the left rather than tunneled straight ahead, this is one of Bierstadt's least imposing mountainscapes. Perhaps at the end of his life, aware of recent developments in American art, he wanted to see if it were possible to make a vast landscape more intimate.

Oil on canvas, 72" × 120" (183 × 305 cm). The Brooklyn Museum, Gift of Mrs. Mary Stewart Bierstadt.

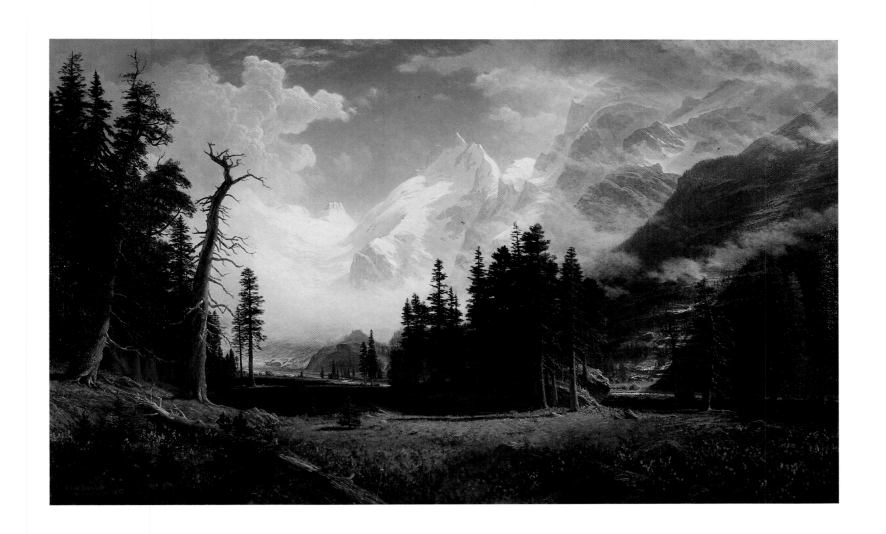

Plate 29

YOSEMITE VALLEY, CALIFORNIA

ca. 1863

Bierstadt's best-known works of Yosemite are the large ones in which the valley's features are easily recognized, but he also painted intimate scenes such as this one. The area provided an inexhaustible source of imagery. In *Yosemite Valley, California*, Bierstadt reveals his sensitivity to the physical presence of landscape forms and how adroitly he could represent them. For this painting appears to be nothing if not a carefully meditated exercise in describing trees, ground cover, and water in varied light when, because of the angle of illumination, textures are most noticeable and palpable. Bierstadt captured that moment in the day when both the surfaces and the solidity of objects are most apparent. The rustling of the leaves in the trees and the scratching of the grasses against each other can almost be felt. Although an intimate scene, *Yosemite Valley, California*, has an openness of design and a generous feeling of space. As in his other middle-sized paintings, Bierstadt here appears most in control of his technical faculties and most willing to reveal his own feelings for the landscape; this is the work of an artist who in private moments feels the pulse of nature and is absorbed by it. Bierstadt's sensibility here is different from that of his mammoth paintings. Yet he probably was able to complete paintings of this type only with the experience of having made larger ones, since they have an expansive and generous scale despite their relatively confined focus.

Oil on paper on canvas, 16″ × 20″ (41 × 51 cm). Lowe Art Museum, Coral Cables, Florida. Gift of Beaux Arts.

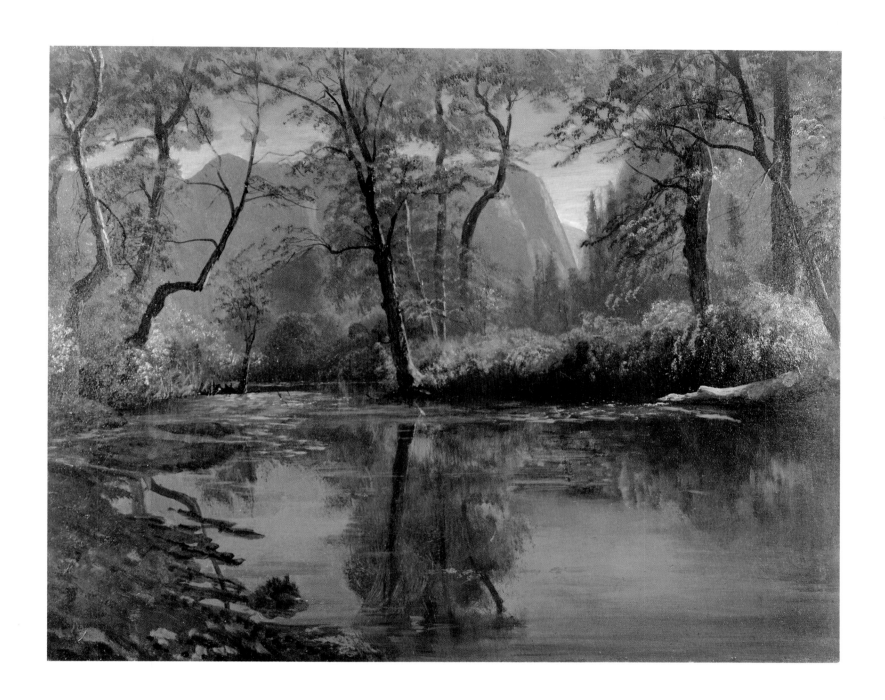

Plate 30

ELK

n.d.

One of the great attractions of the West was its wildlife. The travel literature is filled with the wonders and delights of seeing and shooting antelopes, elk, moose, deer, buffalo, prairie dogs, bears, and other animals. Few, if any, artists of the West studied them as intently and as thoroughly as Bierstadt. Often, he made quick sketches that captured general features. Some studies are of heads or torsos, and some pencil studies are of feet. In several, local terrain is barely indicated; others are more elaborate and include detailed background elements as well as other animals. In many, Bierstadt captured particular lighting conditions of the area. One wonders if sometimes the animals were incidental accessories to his careful scrutiny of these conditions. Regardless of the degree of finish, the animals run, stand, lie, feed, graze, and fight. In the summary sketches, the animals appear almost as if in primitive paintings. At the other extreme, Bierstadt recorded textural differences among facial, neck, and body fur and distinguished among the various muscles. Virtually all the animals appear unposed, as if caught in a candid-camera snapshot. Bierstadt also seized the animals' essential character traits, or at least those traits we have assigned to them: deer look alert, bears self-assured, and buffalo anguished.

Oil on paper, 12¼″ × 18½″ (31 × 47 cm). Courtesy of the Buffalo Bill Historical Center, Cody, Wyoming.

Plate 31

OREGON TRAIL

n.d.

Bierstadt painted several twilight and night scenes illuminated by the afterglow of spectacular sunsets or by moonlight and campfires. In virtually all the twilight scenes, he sought those quiet moments between daylight and dark that are so pleasant in the wilderness. Night scenes required a more immediate content, here a genre scene of pioneers on the trail. Typically, Bierstadt kept the principal action in the middle distance, as in his early works, and resisted describing a specific anecdote. Instead, the activity is typical—washing and building a fire. Although only one wagon is seen, Bierstadt probably intended to show a small encampment. The halt in the day's travel, which had probably taken place hours earlier because of the need to find game, water, and some sort of shelter as well as ground for grazing horses and cattle, was probably the most genial part of the pioneer's day. Community could be reestablished, plans made, and strength replenished. Although the travel literature of the time occasionally recorded violent dissension at these times because of misjudged distances or wrong turns at the wrong pass, Bierstadt depicts the night's camp-out as a refreshing way to pass a few hours. The weather is pleasant and the trees provide shelter, if not haven, in the wilderness. Chores seem easy and the westward trek manageable. Although he obviously experienced rain- and snowstorms and the fright caused by Indians and wild animals, he selected only the more positive aspects of the overland trip.

Paintings of this type show Bierstadt's skill in capturing light effects and, in a telling silhouette, in indicating both the solid bulk of a tree and the implied movement of a person. Even though an orange glow thickly suffuses the atmosphere, he sensitively distinguishes among the varying textures of grass, canvas, and bark, as well as the several colors of those forms.

Oil on canvas, 30″ × 44″ (76 × 112 cm). Kennedy Galleries, Inc., New York.

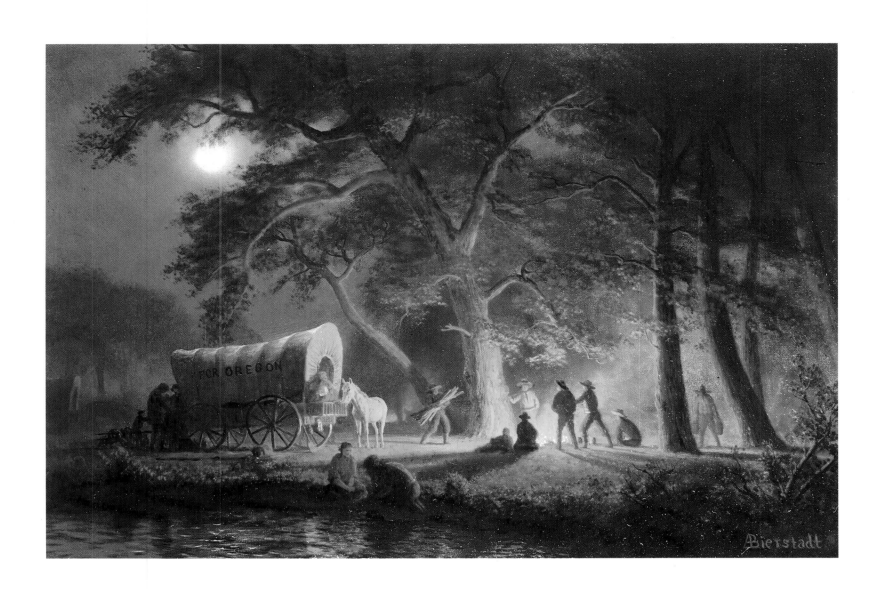

Plate 32

BEACH SCENE

ca. 1871–73

Bierstadt was always aware of the importance of the sky in his works and often brought it into active play as a source of illumination and an element of design. He seemed to delight in painting approaching storms, moonlit scenes, or billowy cloud banks. So varied are his skies and so persistently did they assert themselves in his works that it seems impossible and unnecessary to assign influences. He probably absorbed ideas and techniques from whatever sources were available to him throughout his career, including paintings or reproductions of paintings by Andreas Achenbach and Turner as well as the writings of John Ruskin, especially the lengthly section on clouds in the first volume of his *Modern Painters*, the first American edition of which was published in 1847. The study reproduced here, which is among Bierstadt's more detailed sky scenes, indicates the seriousness with which he studied light sources and cloud formations.

Oil on paper mounted on fiberboard, 13¼″ × 18½″ (34 × 47 cm). The Seattle Art Museum,
Gift of Mrs. John McCone, 69.107. Photo: Paul M. Macapia.

NOTES

1. *The Creative Core of Bierstadt: The Abstract Basis of His Art* (New York: Florence Lewison Gallery, 1963); and Florence Lewison, "The Uniqueness of Albert Bierstadt," *Art in America* 28 (September 1964): 28–33.

2. This is in addition to the critical hedges in which most nineteenth-century critics indulged. For several negative comments, see Gordon Hendricks, *Albert Bierstadt: Painter of the American West* (New York: Harry N. Abrams, 1973), pp. 160, 164, 189–90, 262, 284; Richard S. Trump, "Life and Works of Albert Bierstadt" (Ph. D. diss., The Ohio State University, 1963), p. 192; G. W. Sheldon, *American Painters* (New York: Benjamin Blom, 1972; first published in 1878), p. 149; Charles H. Caffin, *The Story of American Painting* (New York: Frederick A. Stokes, 1907), p. 81.

3. Information can be found in *The Düsseldorf Academy and the Americans* (Atlanta: The High Museum of Art, 1972) and *The Hudson and the Rhine: Die Americakische Malerkolonie in Düsseldorf im 19. Jahrhundert* (Düsseldorf: Kunstmuseum, 1976).

4. "The Collection of Pictures by the Artists of Düsseldorf," *The Crayon* 3 (1956): 22.

5. See especially the essays in *American Light: The Luminist Movement, 1850–1875* (Washington, D.C.: National Gallery of Art, 1980).

6. C. W. Dana, *The Great West, or the Garden of the World: Its History, Its Wealth, Its Natural Advantages, and Its Future* (Boston: Wentworth, 1856), p. 13.

7. Arthur A. Ekirch, Jr., *Man and Nature in America* (New York: Columbia University Press, 1963), p. 24.

8. Cited in Mary Sayre Haverstock, "Can Nature Imitate Art?" *Art in America* 54 (January-February 1966): 73.

9. William H. Goetzmann, *Exploration and Empire: The Explorer and the Scientist in the Winning of the American West* (New York: Norton, 1978; first published in 1966), p. 281; Robert Taft, *Artists and Illustrators of the Old West: 1850–1900* (New York: Charles Scribner's Sons, 1975; first published in 1953), pp. 5–8; Elizabeth M. Cock, "The Influence of Photography on American Landscape Painting, 1839–1880" (Ph.D. diss., New York University, 1967), pp. 55–57; Mr. McDougal, "The Pacific Railroad," *The North American Review* 82 (January 1856): 211–35; and "The Missouri Valley and the Great Plains," *The North American Review* 87 (July 1858): 66–94.

10. Goetzmann, *Exploration and Empire*, p. 303; and Richard A. Bartlett, *Great Surveys of the American West* (Normal: University of Oklahoma Press, 1962), p. xiv.

11. Taft, *Artists and Illustrators*, p. 5; and Weston Naef, *Era of Exploration: The Rise of Landscape Photography in the American West, 1860–1885* (New York: The Metropolitan Museum of Art, 1975), p. 44.

12. *The Crayon* 6 (September 1859): 287. See also Letter to Dear Friends (his students in New Bedford), April 27, 1859, from St. Joseph, Missouri, in the Archives of American Art, roll P-88, frames 4–6.

13. *The Crayon* 3 (January 1856): 28.

14. *The New Path* 11 (March 1864): 161.

15. In George Bancroft, *Spirit of the Fair*, cited in Gordon Hendricks, "Bierstadt and Church at the New York Sanitary Fair," *Antiques* 102 (November 1972): 897.

16. Samuel Bowles, *Across the Continent* (New York: Hurd and Houghton), p. 70.

17. Cited in Trump, "Life and Works," p. 130.

18. H. T. Tuckerman, "Albert Bierstadt," *The Galaxy* 1 (August 15, 1866): 680, seen in the Archives of American Art, roll N. Y. 59–11, frames 614–17.

19. Paul Shepherd, *Man in the Landscape* (New York: Ballantine, 1972; first published in 1967); pp. 177–78. Shepherd does not cite the particular source in Irving's work.

20. James Jackson Jarves, *The Art Idea* (New York: Hurd and Houghton, 1864), p. 233.

21. Clarence King, *Mountaineering in the Sierra Nevada* (London: Sampson, Low, Marston, Low and Searle, 1872). See also Goetzmann, *Exploration and Empire*, pp. 430–66. Bierstadt spent several weeks with King near Mount Whitney in 1872.

22. King, *Mountaineering*, p. 11.

23. Ibid., p. 126.

24. Bowles, *Across the Continent*, pp. xviii, 33.

25. Mrs. J. H. Layton, "American Art," *The Knickerbocker* 58 (July 1861): 48–52.

26. Tuckerman, "Albert Bierstadt," p. 682; and H. T. Tuckerman, *Book of the Artists* (New York: G. P. Putnam's Sons, 1870), pp. 395–96.

27. William Gilpin, *The Central Gold Region, the Grain, Pastoral, and Gold Regions of North America* (Philadelphia: Sower, Barnes, 1860; reissued as *Mission of the North American People* in 1873).

28. Ibid., pp. 18–20.

29. Ibid., p. 65.

30. Ernest Tuveson, *Redeemer National: The Idea of America's Millennial Role* (Chicago: University of Chicago Press, 1968), pp. 102–22, 171–73.

31. The literature on the subject is vast, but see Tuveson, *Redeemer Nation*; Frederick Merk, *Manifest Destiny and Mission in American History* (New York: Vintage Books, 1966; first published in 1963); and Rush Welter, *The Mind of America: 1820–1860* (New York: Columbia University Press, 1975).

32. George W. Julian, "Our Land Policy," *The Atlantic Monthly* 63 (March 1879): 325–37.

33. *Harper's New Monthly Magazine* 17 (1858): 699.

34. Information based on Cock, "The Influence of Photography"; Elizabeth Lindquist-Cock, "Stereoscopic Photography and the Western Paintings of Albert Bierstadt," *The Art Quarterly* 33 (1970): 360–78; Gordon Hendricks, "The First Three Western Journeys of Albert Bierstadt," *The Art Bulletin* 46 (September 1964): 333–65; William Culp Darrah, *Stereo Views: A History of Stereographs in America and Their Collection* (Gettysburg: Time and News Publishing Co., 1964); and Donald S. Strong, review of Hendricks's *Albert Bierstadt* in *American Art Review* 2 (November-December 1975): 132–44.

35. Jarves, *Art Idea*, p. 233.

36. Catherine Campbell of the Smith College Museum of Art, which owns *Echo Lake*, believes a direct relationship exists between the painting and family photographs of the area.

37. Lindquist-Cock, "Stereoscopic Photography," p. 376.

38. King, *Mountaineering*, p. 210.

39. Shepherd, *Man in the Landscape*, p. 143.

40. Rhode Island School of Design, *Museum Bulletin* 63 (April 1977): 35.

41. John W. McCoubrey, *American Tradition in Painting* (New York: George Braziller, 1963), pp. 27–28.

42. Hendricks, "First Three Western Journeys," p. 339; and Cock, "Influence of Photography," pp. 69–76.

43. Cocks, "Influence of Photography," p. 86; and Cock-Lindquist, "Stereoscopic Photography," p. 371.

44. The sketchbook was discovered by Barbara Listokin.

45. Robert F. Berkhofer, Jr., *The White Man's Indian* (New York: Alfred A. Knopf, 1978), pp. 86–95.

46. Ibid., p. 95.

47. Goetzmann, *Exploration and Empire*, p. 328.

48. See the discussion in the essay, pp. 10–11.

49. See illustrations in Goetzmann, *Exploration and Empire*; Taft, *Artists and Illustrators*; *The Western Frontier* (Denver: Denver Art Museum, 1966).

50. Strong, review of Hendricks's *Albert Bierstadt*, p. 137.

51. Parkman, *Oregon Trail*, pp. 258–59.

52. Fitz Hugh Ludlow, *The Heart of the Continent* (New York: Hurd and Houghton, 1870), pp. 110–12, cited in Hendricks, *Albert Bierstadt*, p. 123. See also Francis Parkman, *The Oregon Trail* (New York: New American Library, 1950; first published in 1849), p. 50.

53. "Settlement of Oregon—Emigrants of 1843," 29th Cong., 1st sess., Senate Document no. 306. Report of the Committee on the Post Office and Post Roads (April 20, 1846), cited in Henry Nash Smith, *Virgin Land* (New York: Vintage Books, 1950), pp. 39–40.

54. "The Upper Mississippi," *Harper's New Monthly Magazine* 94 (March 1858): 438.

55. King, *Mountaineering*, pp. 144, 146.

56. See the discussion in the essay, p. 9.

57. Clarence S. Jackson, *Picture Maker of the Old West* (New York: Charles Scribner's Sons, 1947), illustration on p. 206.

58. Hendricks, *Albert Bierstadt*, p. 217.

59. *M. and M. Karolik Collection of American Paintings, 1815 to 1865* (Boston: The Museum of Fine Arts, 1949), p. 96.

60. Rena N. Coen, "The Last of the Buffalo," *The American Art Journal* 5 (November 1973): 84.

61. From an undated clipping (probably March 1889) from *The New York World*, cited in Hendricks, *Albert Bierstadt*, p. 291.

62. Ibid., p. 207.

63. Merk, *Manifest Destiny*, chapter 11.

64. Hendricks, *Albert Bierstadt*, pp. 311–12.

65. Berkhofer, *White Man's Indian*, pp. 49–61.

SELECTED BIBLIOGRAPHY

"Albert Bierstadt." *California Art Research* 2, 1st ser. (January 1937): 98–130.

Bendix, Howard E. "The Stereographs of Albert Bierstadt." *Photographia*, September-November 1974.

Bierstadt, His Small Paintings. New York: Florence Lewison Gallery, 1968.

"Cinemascopic West of Albert Bierstadt." *Nineteenth Century* 3 (Autumn 1977): 55–59.

The Creative Core of Bierstadt: The Abstract Basis of His Art. New York: Florence Lewison Gallery, 1963.

Draper, Benjamin Poff. "Albert Bierstadt." *Art in America* 28 (April 1940): 61–71.

Heller, Nancy, and Williams, Julia. "Albert Bierstadt: The American Wilderness." *American Artist* 40 (January 1976): 52–57.

Hendricks, Gordon. *ABierstadt*. Fort Worth: The Amon Carter Museum of Western Art, 1972.

————. *Albert Bierstadt*. New York: Knoedler, 1972.

————. *Albert Bierstadt: Painter of the American West*. New York: Harry N. Abrams, 1973.

————. "Bierstadt and Church at the New York Sanitary Fair." *Antiques* 102 (November 1972): 892–98.

————. "The Domes of the Yosemite." *The American Art Journal* 3 (Fall 1971): 23–31.

————. "The First Three Western Journeys of Albert Bierstadt." *The Art Bulletin* 46 (September 1964): 333–65.

Lewison, Florence. "The Uniqueness of Albert Bierstadt." *American Artist* 28 (September 1964): 28–33.

Lindquist-Cock, Elizabeth. "Stereoscopic Photography and the Western Paintings of Albert Bierstadt." *The Art Quarterly* 33 (Winter 1970): 360–78.

Man, Beast and Nature. New York: Florence Lewison Gallery, 1964.

A Selection of Paintings by Albert Pinkham Ryder and Albert Bierstadt. New Bedford: Swain School of Design, 1960. Essay by Richard S. Trump.

Snell, Joseph. "Some Rare Western Photographs of Albert Bierstadt Now in the Historical Society Collections." *Kansas Historical Quarterly* 24 (September 1958): 1–5.

Strong, Donald. Review of Gordon Henricks's *Albert Bierstadt: Painter of the American West*. *American Art Review* 2 (November-December, 1975): 132–44.

Trump, Richard S., "Life and Works of Albert Bierstadt," Ph.D. diss., The Ohio State University, 1963.

INDEX

Edited by Betty Vera
Designed by Jay Anning
Graphic production by Ellen Greene
Text set in 10-point Goudy Oldstyle